The 1950s

BRITAIN IN PICTURES

The 1950s

BRITAIN IN PICTURES

AMMONITE PRESS

PRESS ASSOCIATION Images

First Published 2012 by
Ammonite Press
an imprint of AE Publications Ltd,
166 High Street, Lewes, East Sussex, BN7 1XU

This title has been created using material first published in
Britain in Pictures: The 1950s (2008).

Text © AE Publications Ltd, 2012
Images © Press Association Images, 2012
Copyright © in the work AE Publications Ltd, 2012

ISBN 978-1-907708-56-5

British Cataloguing in Publication Data. A catalogue
record of this book is available from the British Library.

Editor: Ian Penberthy
Series Editor: Richard Wiles
Picture research: Press Association Images
Design: Gravemaker + Scott

Colour reproduction by GMC Reprographics
Printed and bound in China by C&C Offset Printing Co. Ltd

Page 2: Christmas
decorations in Regent Street.
2nd December, 1955

Page 5: The world's motor
manufacturers await the
British public at the Motor
Show, Earl's Court, London.
20th October, 1959

Page 6: Two girls enjoying
the prospect of strawberry
picking near the Somerset
town of Cheddar.
1st June, 1956

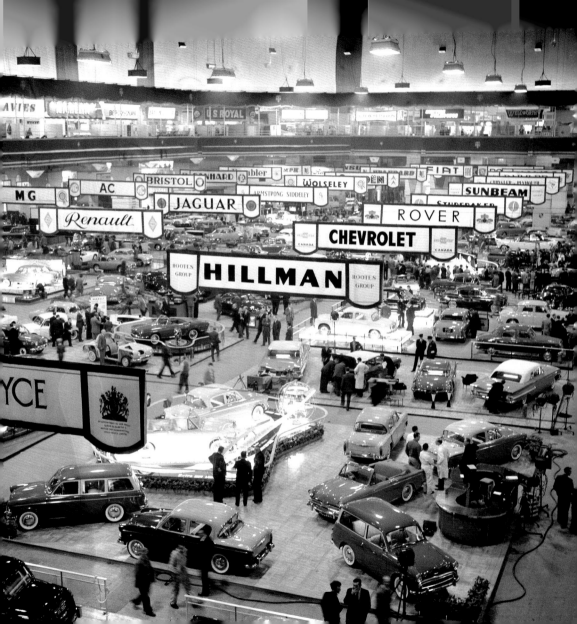

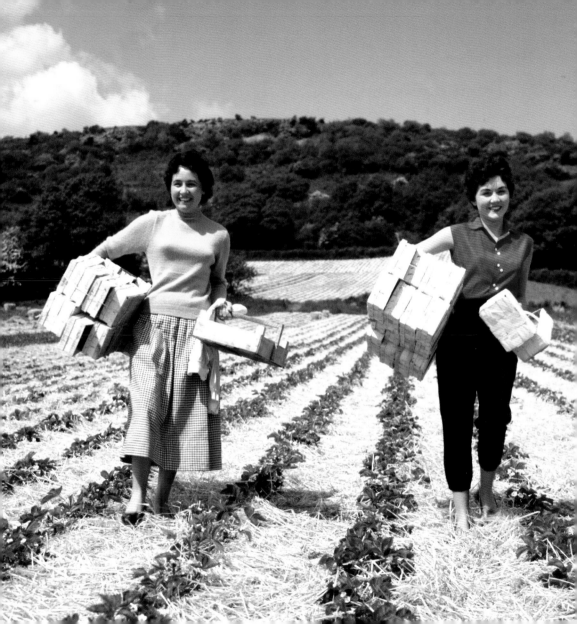

Introduction

The archives of PA Photos yield a unique insight into Britain's recent past. Thanks to the science of photography we can view the 20th Century more accurately than any that came before, but it is thanks to news photography, and in particular the great news agency that is The Press Association, that we are able now to witness the events that made up life in Britain, not so long ago.

It is easy, looking back, to imagine a past neatly partitioned into clearly defined periods and dominated by landmarks: wars, political upheaval and economic trends. But the archive tells a different story: alongside the major events that constitute formal history are found the smaller things that had equal – if not greater – significance for ordinary people at the time. And while the photographers were working for that moment's news rather than posterity, the camera is an undiscriminating eye that records everything in its view: to modern eyes it is often the backgrounds of these pictures, not their intended subjects, that provide the greatest fascination. Likewise it is revealed that Britain does not pass neatly from one period to another.

The decade between 1st January, 1950 and the 31st December, 1959, standing as it does at the mid-point of the century, illustrates this perfectly. The world's first regular jet aircraft passenger service commenced in 1952, yet the last working oxen in the country were still ploughing in 1959. The Festival of Britain fixed its eyes on a modernistic horizon, but rationing of basic foods continued well into the decade. Shadows of the previous decade's war inevitably persisted, darkened by the conflicts in Korea and Suez. The people who populate these pages could not have known what the next decade held for them, but with our hindsight the signs are there to see: in the 1950s the teenager emerges as a distinct social group with its own culture, no longer merely an awkward intermediate stage between childhood and adult life. The new medium of television takes its place as both recorder of, and influence on, life in Britain.

Thus the past and future meet gradually, mingling and gently colliding in a process of ceaseless change in the journey from what has been, to what will be.

Prospective cricket coaches
practise their batting
technique at a coaching
school organised by Essex
County Cricket Club.
2nd January, 1950

Children in fancy dress at the Children's Party for Blind Children, Hyde Park Hotel.
5th January, 1950

Two gentlemen examine a new weather vane at Twickenham rugby ground. Designed by Kenneth Dalgliesh, it features Hermes, the messenger of the Gods, passing a ball to a modern-day rugby player.
18th January, 1950

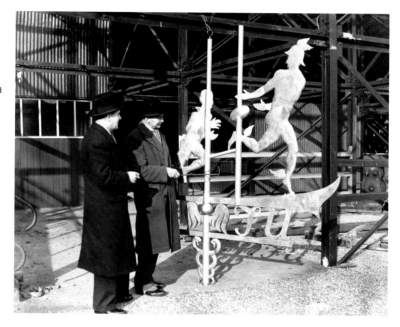

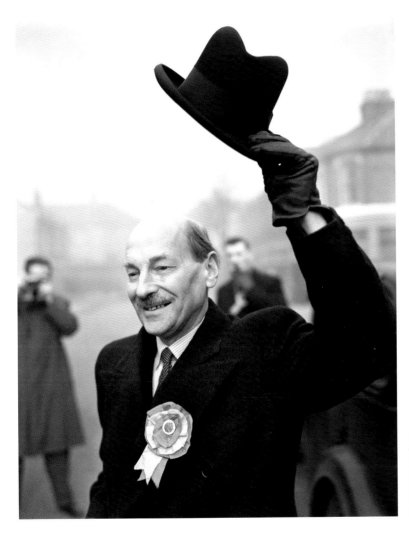

Premier Clement Attlee expresses eve of poll confidence with a wave of his hat, as he tours his constituency at Walthamstow.

22nd February, 1950

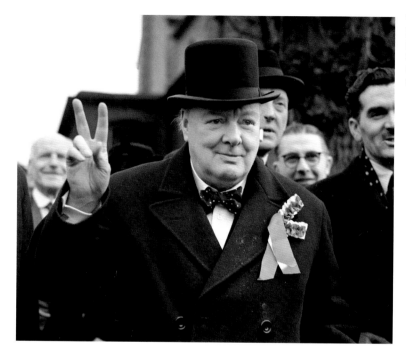

Winston Churchill gives his signature 'victory' sign as he makes an election day tour of his Woodford constituency.
23rd February, 1950

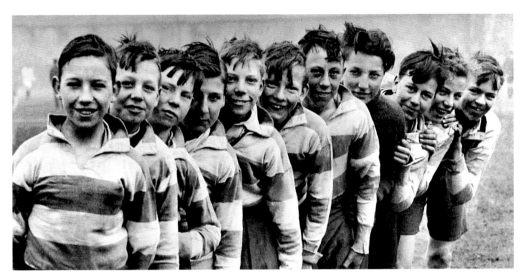

West Ham Schoolboys football team poses for the camera.
1st March, 1950

A combination clothing and dishwashing machine by 'Thor', at the Ideal Home Exhibition, Olympia.
3rd March, 1950

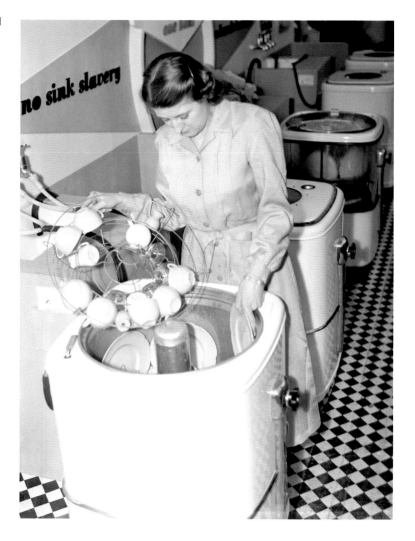

A policeman talks to a colleague on his new-fangled walkie-talkie.
4th March, 1950

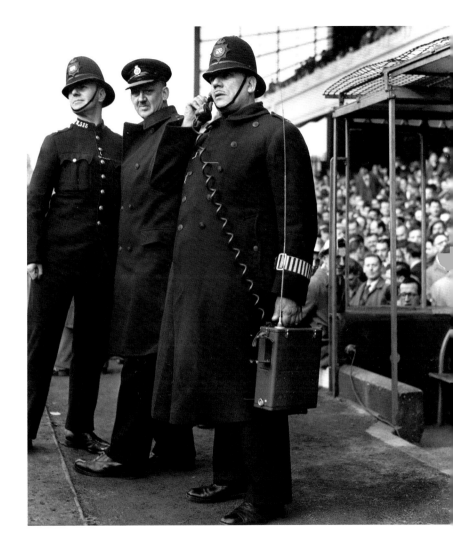

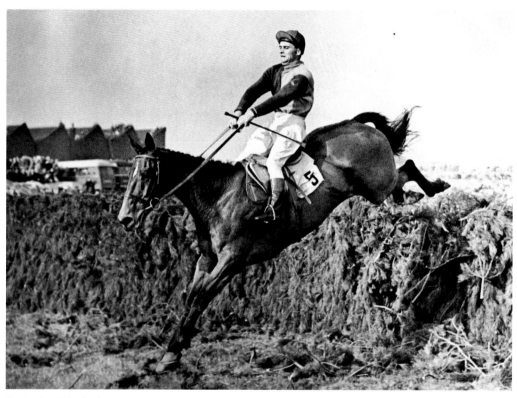

Freebooter, ridden by Jimmy
Power, clears the last fence
on his way to winning the
Grand National.
25th March, 1950

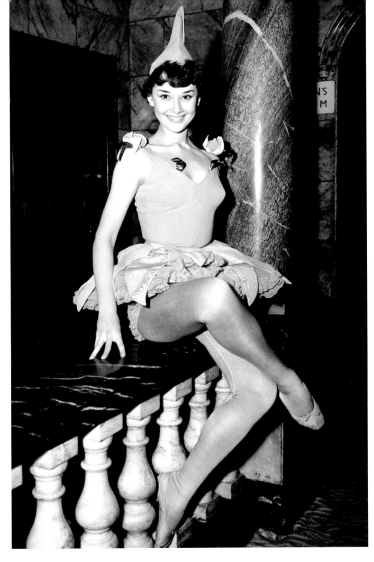

Audrey Hepburn dressed as a tulip, her costume designed by Honoria Plesch, at the Cambridge Theatre preview of Cecil Landeau's *Sauce Piquante*.

17th April, 1950

Eighteen-year-old British-American actress Elizabeth Taylor stands in as a cigarette girl at a charity function in Hollywood, USA.
21st April, 1950

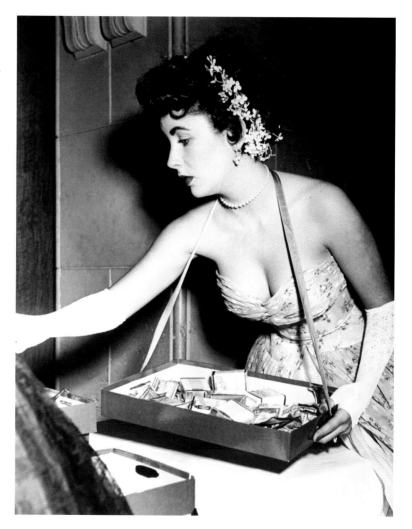

Miss Daphne Sole of
Regent's Park, inspecting
a set of spun aluminium
pans at the Murray House
Exhibition Hall, London.
25th April, 1950

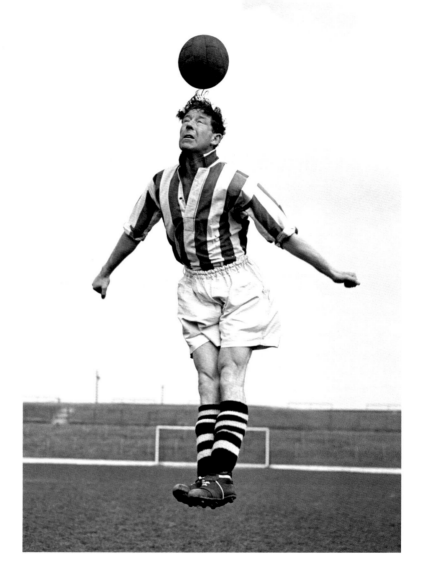

West Bromwich Albion's
Jack Vernon, in mid flight.
27th April, 1950

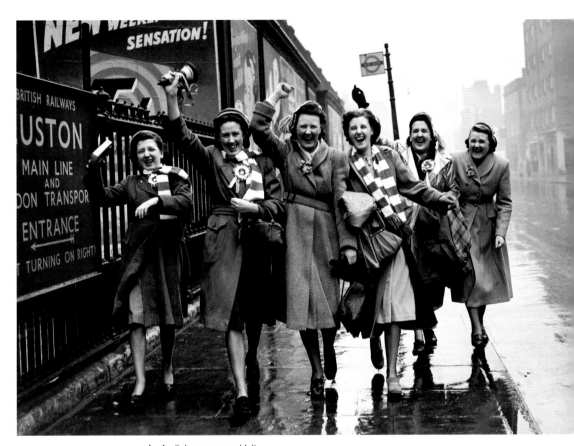

An April downpour couldn't dampen the enthusiasm of these Liverpool girls, as they toured London on their way to Wembley Stadium.
29th April, 1950

Liverpool captain Phil Taylor
shakes hands with King
George VI before the FA
Cup Final with Arsenal.
29th April, 1950

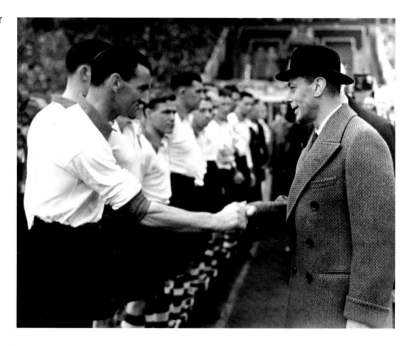

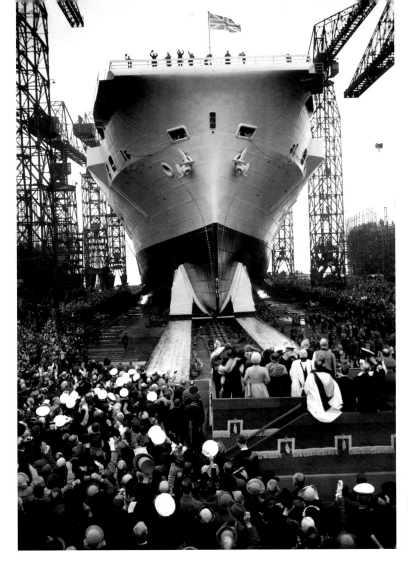

The Queen launching the
Ark Royal, Britain's most
powerful aircraft carrier,
from the Birkenhead yard of
Cammell Laird.
3rd May, 1950

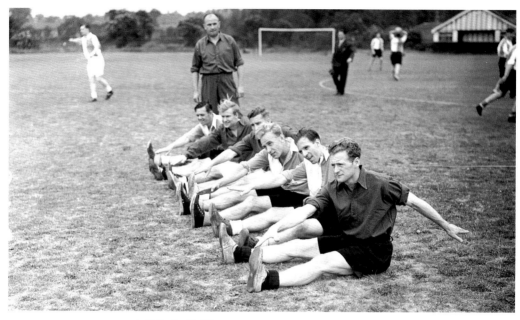

L–R: England's Bill Eckersley, Wilf Mannion, Roy Bentley, Billy Wright, Eddie Baily and Tom Finney during training at Dulwich for the Brazil World Cup.

13th June, 1950

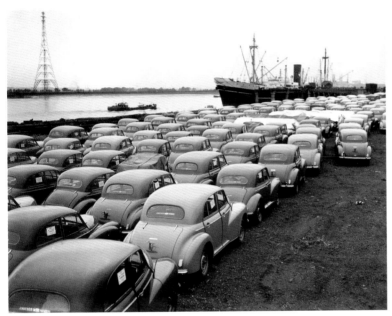

500 Morris Minors at the Samuel Williams wharf of the London docks, part of a one million dollar consignment destined for Canada to earn the precious dollar.

27th June, 1950

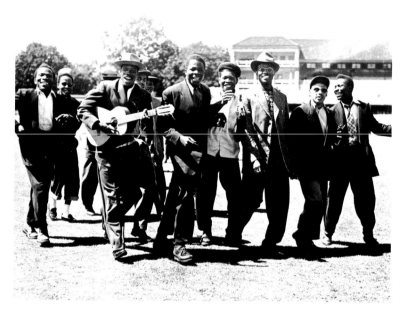

West Indies cricket fans celebrate on the pitch after seeing their team beat England by 326 runs on the fifth day of the Second Test.
29th June, 1950

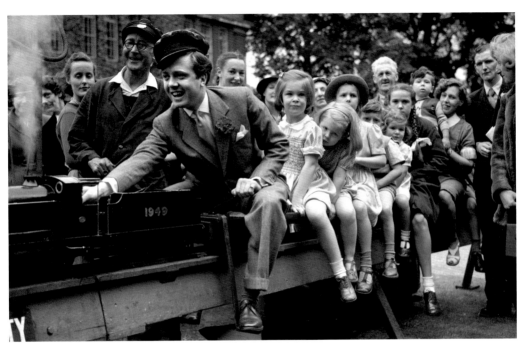

Richard Attenborough
pilots a trainload of children
during a carnival at Bedford
College, Regents Park.
25th July, 1950

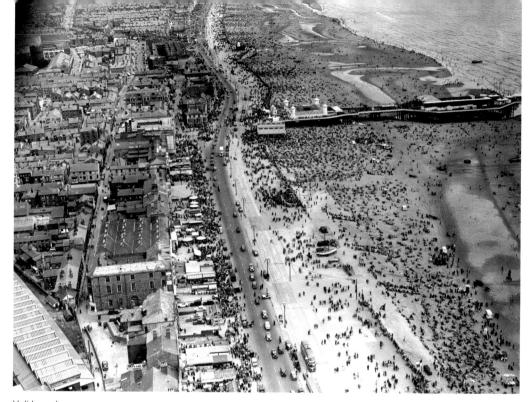

Holidaymakers on
Blackpool beach.
8th August, 1950

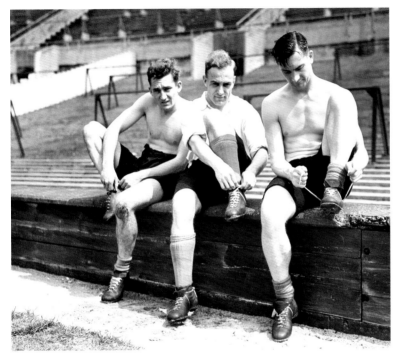

England's Roy Bentley, Billy Wright and Jackie Milburn get ready for a training session.
10th August, 1950

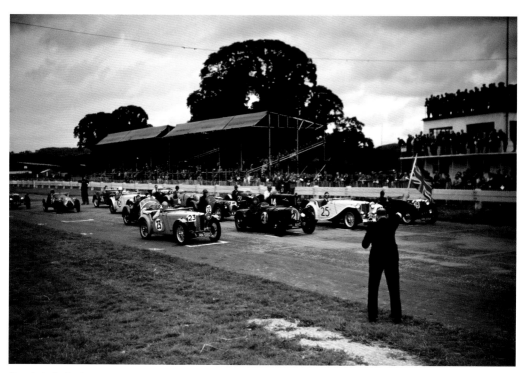

The start of a five lap
scratch race, up to 1100cc,
at Goodwood.
12th August, 1950

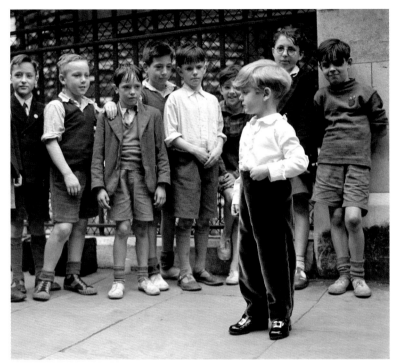

Four-year-old Nicholas Goodman outside St James' Church, Spanish Place, London, where he was page at the wedding of Jill Raymond to Clement Freud.

4th September, 1950

Three Manchester children on the *Rangitikei* boat train leaving Liverpool Street station, chosen to become settlers in New Zealand by the Overseas League.
8th September, 1950

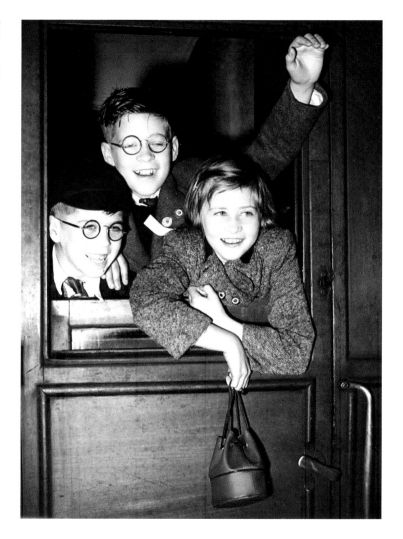

The 1950s • Britain in Pictures

Sailors board the light aircraft carrier HMS *Warrior* at Portsmouth, on their way to relieve sailors already on duty in the Korean War. In the background is Lord Nelson's historic flagship HMS *Victory*.

18th September, 1950

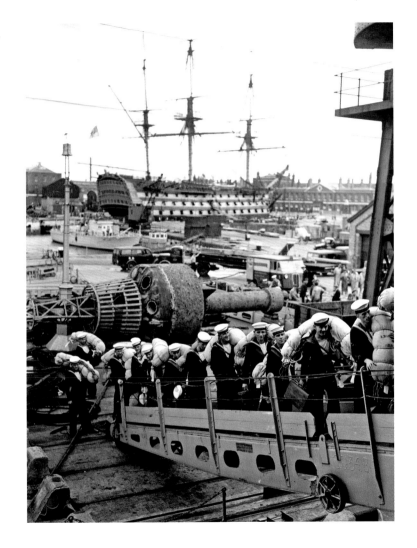

Liverpool goalkeeper
Cyril Sidlow, at a Football
League Division One match
against Fulham.
23rd September, 1950

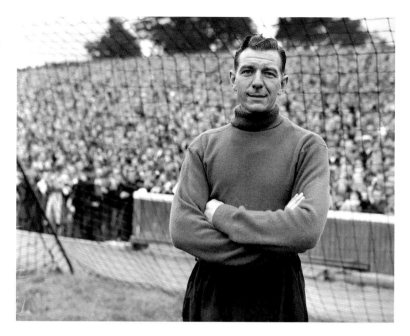

A factory worker with guy
and fireworks, in the run up
towards Bonfire Night on 5th
November.
12th October, 1950

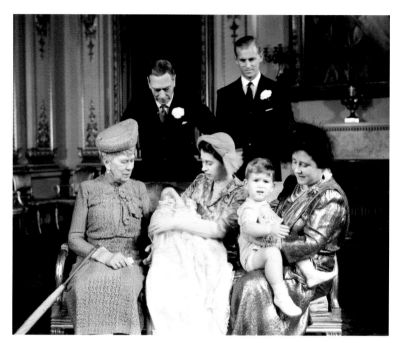

Princess Anne, daughter of Princess Elizabeth (C) and the Duke of Edinburgh (standing, R), was christened at Buckingham Palace. The family group also includes King George VI (standing, L), Queen Mary (L), Queen Elizabeth (R) and Prince Charles (second R).
21st October, 1950

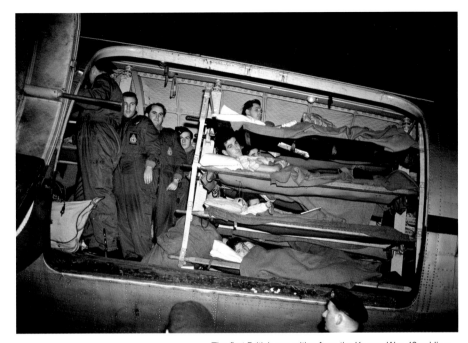

The first British casualties from the Korean War, 12 soldiers, arrive at RAF Lyneham, Wiltshire aboard a Handley Page HP67 Hastings of RAF Transport Command. With them in the aircraft is a two-year-old boy suffering from poliomyelitis, Peter Mounsey (second from bottom), the son of the medical officer at RAF Changi, Singapore.

22nd November, 1950

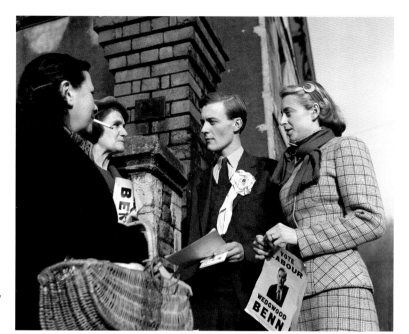

Anthony Wedgwood Benn and his wife Caroline (R), carrying the Labour Party's banner, in a three-cornered battle for Sir Stafford Cripps' old seat in Bristol SE.

28th November, 1950

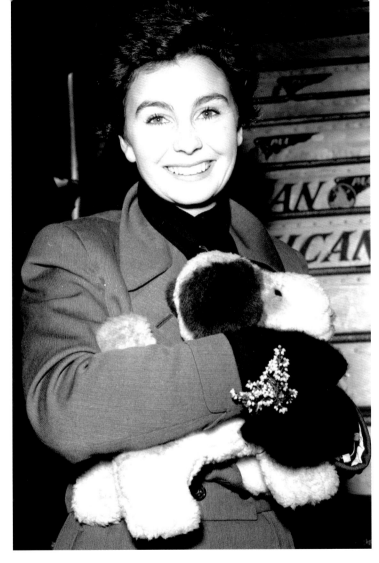

Film star Jean Simmons
boards a Pan American
Clipper for America at
London Airport, having been
awarded an OBE in the New
Year's Honours List.
7th December, 1950

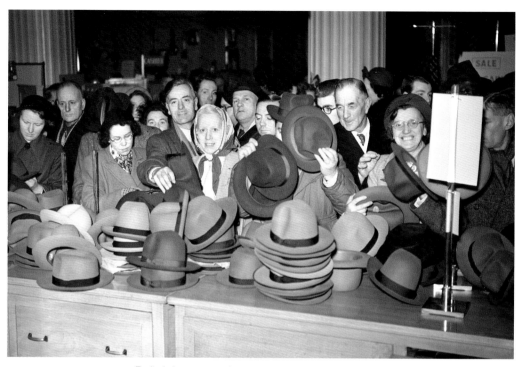

Excited shoppers crowd
around a hat stall in
London's Selfridges during
the winter sales.
1st January, 1951

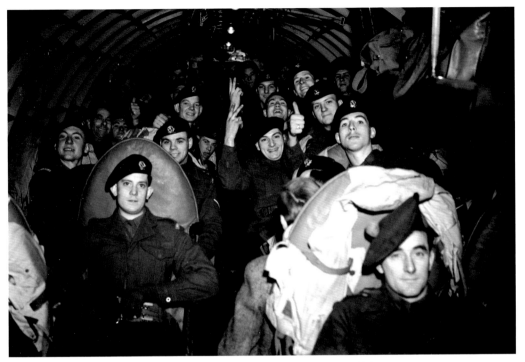

Reinforcements for British
units in Korea setting out
from RAF Lyneham in
Wiltshire.
12th January, 1951

Sir Laurence Olivier speaks on the state of the post-war film industry. Distribution of British films in the USA had been hampered by a tax crisis in 1947. To help deal with the balance of payments crisis following the war, the British government imposed a 75% tax on foreign film earnings. Since Britain was America's major overseas market, the US imposed a boycott that lasted eight months. An agreement in 1948 resolved the crisis by instituting a quota system, but to meet this US companies in Britain produced a series of low-budget movies. Instead of stimulating home industry, the crisis contributed to large production losses.

21st January, 1951

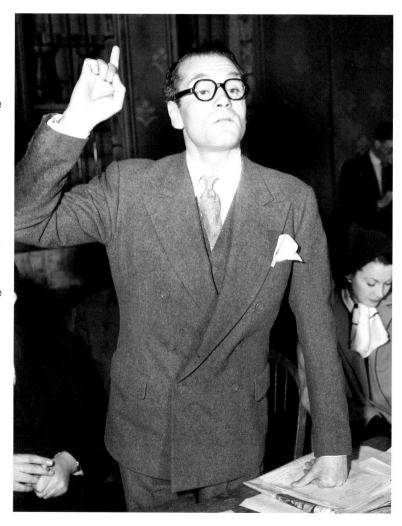

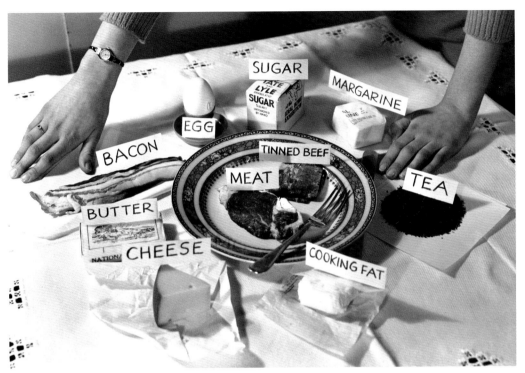

One person's weekly portion of rationed foods. To buy rationed items, each person had to register at chosen shops and was given a ration book containing coupons; the relevant coupon or coupons were cancelled when buying these items. Sweet rationing ended in February 1953 and sugar rationing in September 1953, although the end of all food rationing did not come until 4th July, 1954, with meat the last to become freely available again.

10th February, 1951

The 1951 Five Nations Championship was the twenty-second series of the rugby union Five Nations Championship and the fifty-seventh series of the northern hemisphere rugby union championship. Ten matches, contested by England, France, Ireland, Scotland and Wales, were played between 13th January and 7th April. In this match between England and France, held in London, France's Michel Panathios (R) sprints down the wing. England lost 3–11.

24th February, 1951

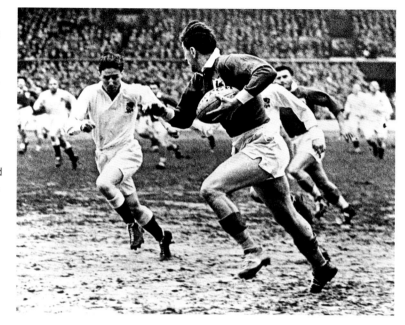

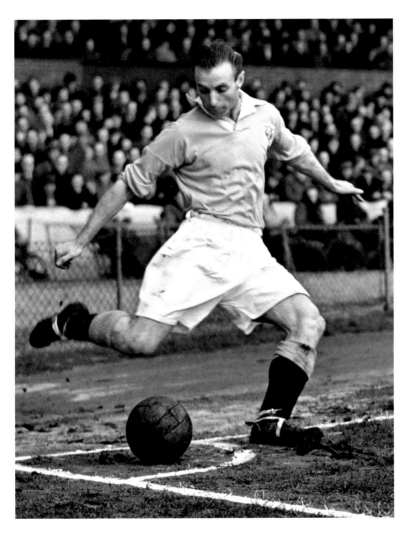

Blackpool footballer Stanley Matthews taking a corner, during the First Division match against Chelsea at Stamford Bridge, London.
28th February, 1951

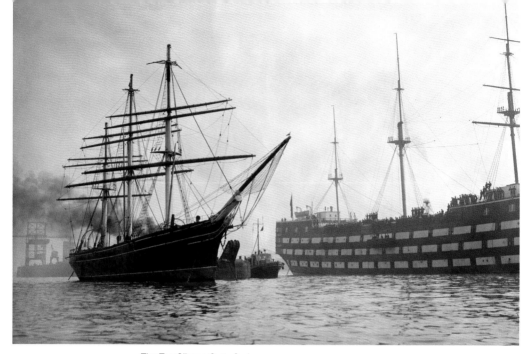

The Tea Clipper *Cutty Sark*
at anchor off Greenhithe on
the Thames, berthed next
to the naval training vessel
HMS *Worcester*.
28th February, 1951

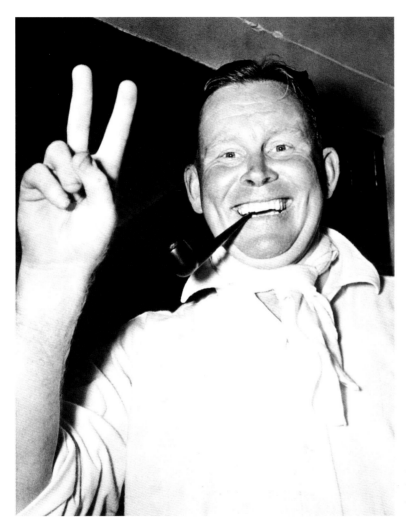

England cricket captain
Freddie Brown celebrates
victory in the final Test, his
team's only win in the whole
Ashes series.
28th February, 1951

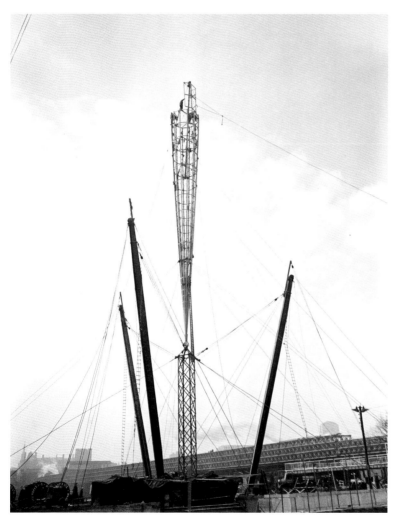

Skylon under construction on the South Bank of the River Thames, London in preparation for the Festival of Britain. The tower was a futuristic-looking, slender, vertical, cigar-shaped steel 'tensegrity' structure, which would apparently float above the ground. A popular joke at the time was that Skylon, like the British government, had no visible means of support.
20th March, 1951

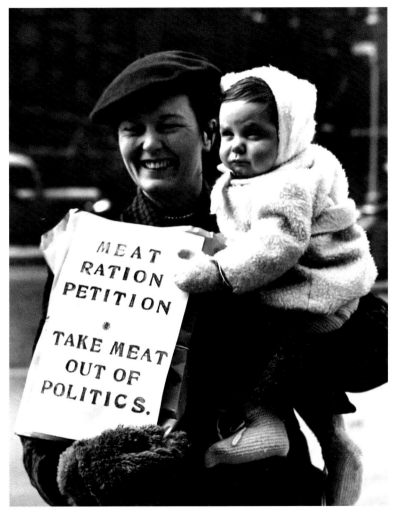

Actress Mary Clare headed housewives who presented a petition – signed by 166,000 people – to the House of Commons, London.
20th March, 1951

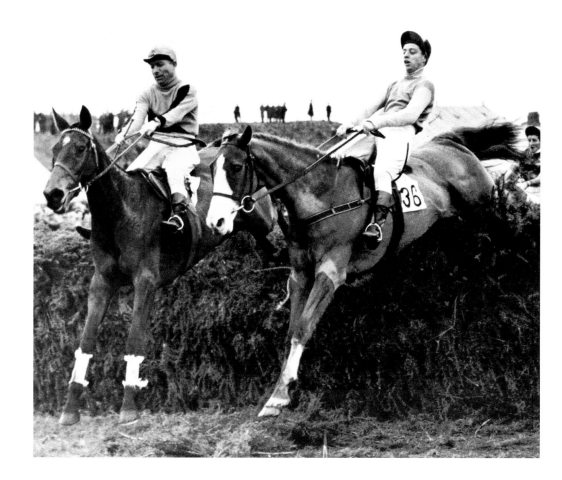

The Royal Festival Hall opens as the most up-to-date concert venue in Britain. Here, some of the Hall's modernistic boxes appear to be floating in mid-air.
27th April, 1951

Facing page: Eventual Grand National winner Nickel Coin (L) with Johnny Bullock up, and Gay Heather with R. Curran in the saddle, take the 17th fence together at Aintree racecourse.
7th April, 1951

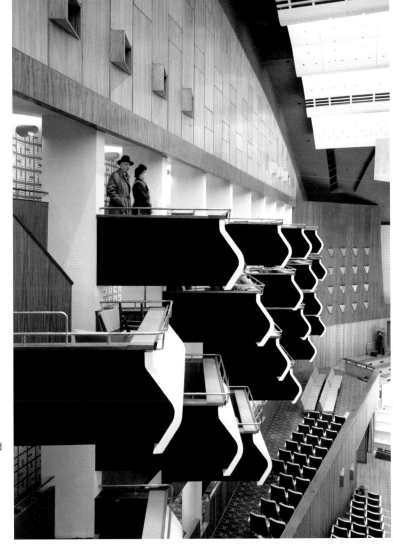

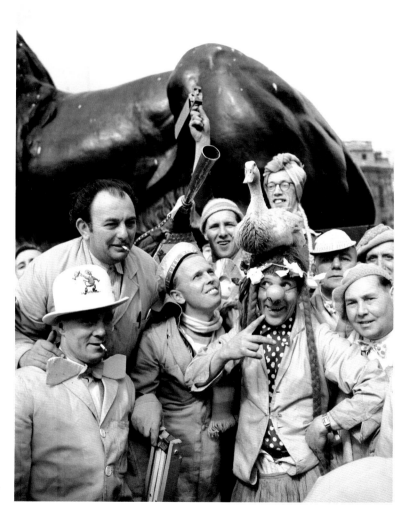

Blackpool football fans before their team's FA Cup Final against Newcastle United at Wembley Stadium. **28th April, 1951**

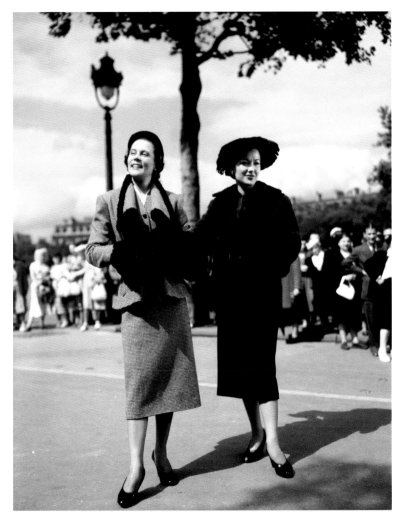

Two wool outfits by Nina Ricci of Paris are modelled on London's south bank. Left is 'Rosa Bonheur', a black and white check suit trimmed with astrakhan, and right is 'La Valliere', a violet blue jacket trimmed with astrakhan, worn over a straight black skirt.

1st May, 1951

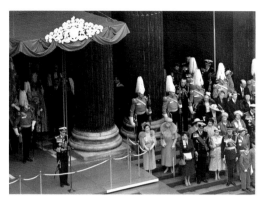

King George VI opens the Festival of Britain. His speech is broadcast to the world. Described by the Labour Party's deputy leader Herbert Morrison as a *"tonic for the nation"*, the Festival was a series of exhibitions aimed at giving the population a sense of pride, and a feeling of recovery and progress after the grim wartime years of the 1940s.
3rd May, 1951

A nighttime view from Westminster Bridge, the day after the opening of the Festival of Britain by King George VI, showing the shimmering Skylon and behind it the illuminated Shot Tower, the only original building left standing on the site, formerly used in the manufacture of shot balls through the freefall of molten lead. To the right of Skylon is the Royal Festival Hall and the Dome of Discovery.
4rd May, 1951

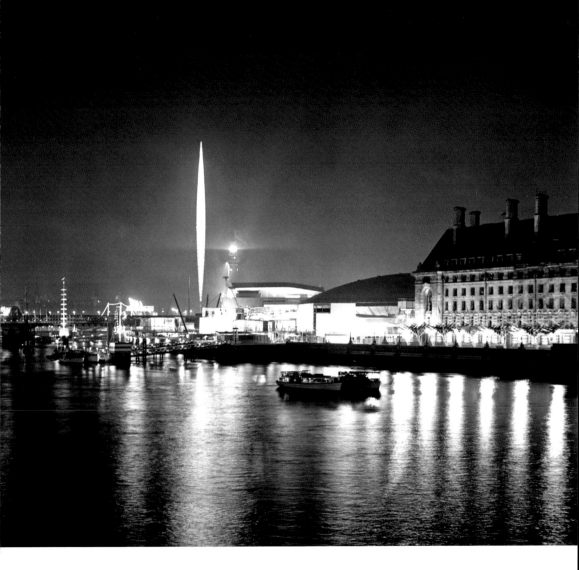

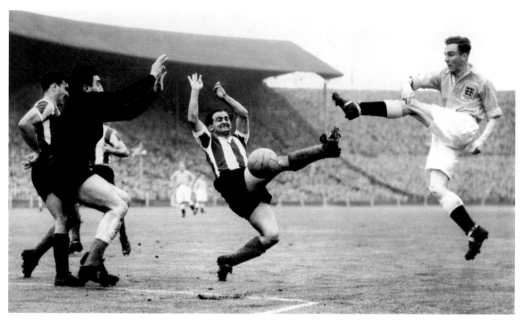

Argentina goalkeeper
Miguel Rugilo (L) blocks a
shot from England's Harold
Hassall (R) with the help of
two teammates in a friendly
football match.
9th May, 1951

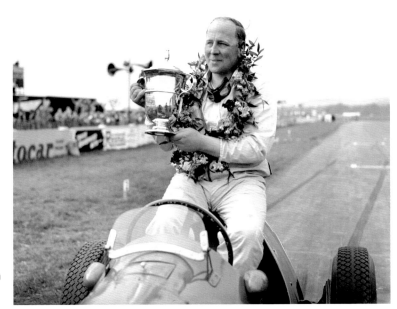

Racing driver Reg Parnell shows off the Festival of Britain Trophy after his win in the final at Goodwood.
14th May, 1951

Spectators watching the MCC (Marylebone Cricket Club) play against South Africa at Lord's.
19th May, 1951

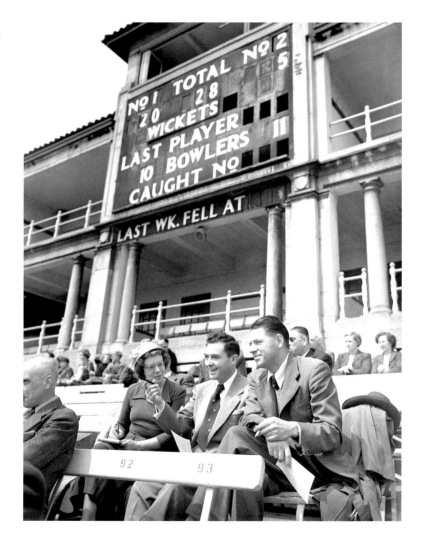

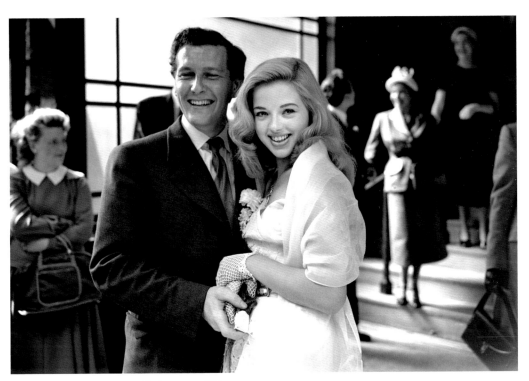

Nineteen-year-old film
actress Diana Dors and
her new husband Dennis
Hamilton, 26-year-old
representative of an
engineering firm, leaving
Caxton Hall register office
after their wedding.
3rd July, 1951

A baker's roundsman delivers bread from his hand cart. Daily house to house bread deliveries were once as routine as milk, there being sufficient demand for more than one bakery to serve an area.

13th July, 1951

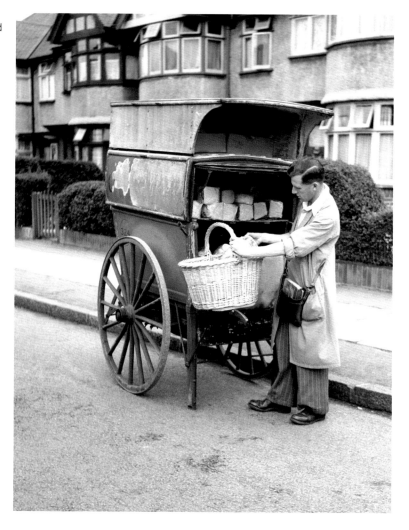

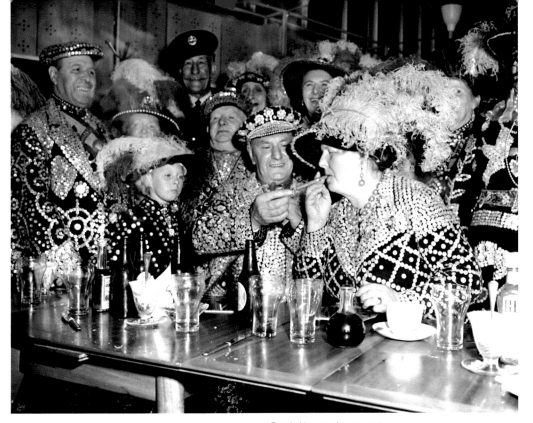

Pearly kings and queens at
a Southbank exhibition in
London. Here Mr J. Marriot,
the Pearly King of Finsbury,
lights a cigar for his wife.
25th July, 1951

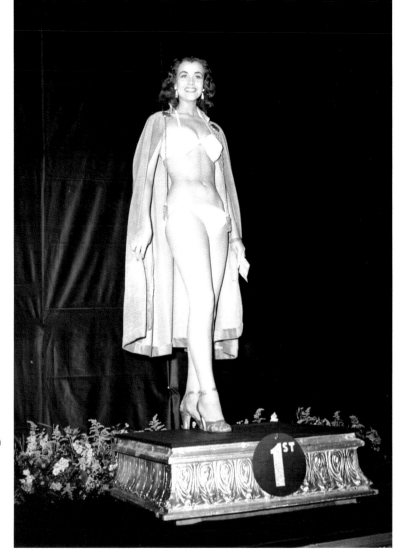

Kerstin 'Kiki' Håkansson (22) was the winner of the first Miss World beauty pageant, held at the Lyceum Theatre, London. She represented Sweden and was the only winner to wear a bikini for the crowning ceremony.
27th July, 1951

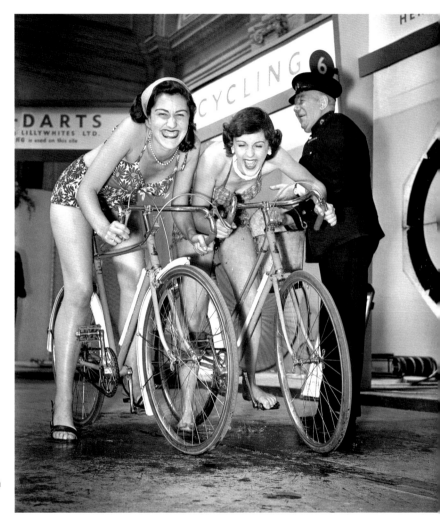

Two young ladies receive a soaking from an attendant as they try out the latest Raleigh bicycles at the British Sports and Games Fair.
28th July, 1951

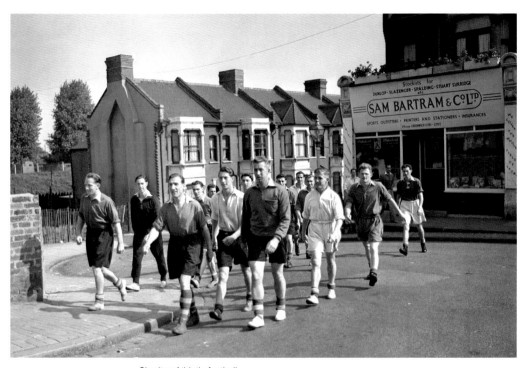

Charlton Athletic football
players pass goalkeeper
Sam Bartram's shop –
sports outfitters, printers and
stationers, insurances – as
they warm up for training
with a brisk walk.
1st August, 1951

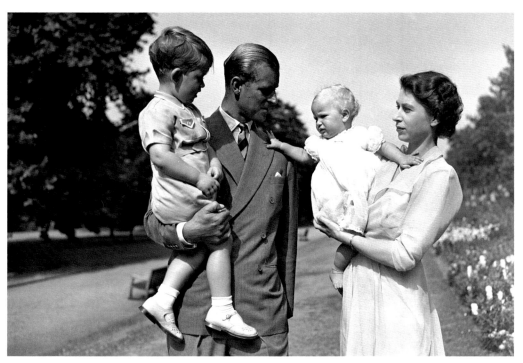

Princess Anne in the arms of Princess Elizabeth, with the Duke of Edinburgh holding Prince Charles, in the grounds of Clarence House, their London residence.
9th August, 1951

Orson Welles, the American author, actor and producer, leaves Heathrow Airport for Rome, towards the end of filming *Othello*. Welles not only wrote the screenplay based on Shakespeare's play, but also produced and directed, while taking the load role.

30th August, 1951

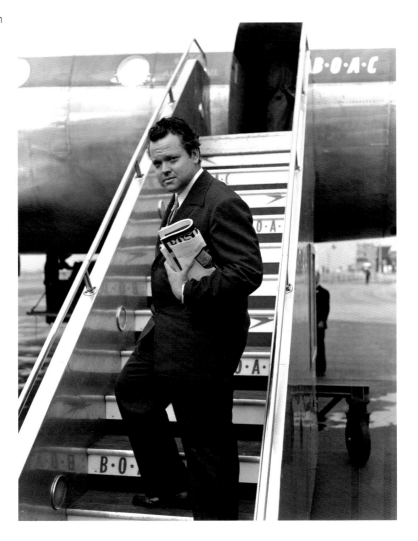

Lance-Corporal Walter Cleveland, MM, on his return from Korea. Cleveland, one of the survivors of the 1st Bn. Gloucestershire Regiment, won his medal during the Imjin battle where, surrounded by the enemy, he carried a wounded man for four miles.

14th September, 1951

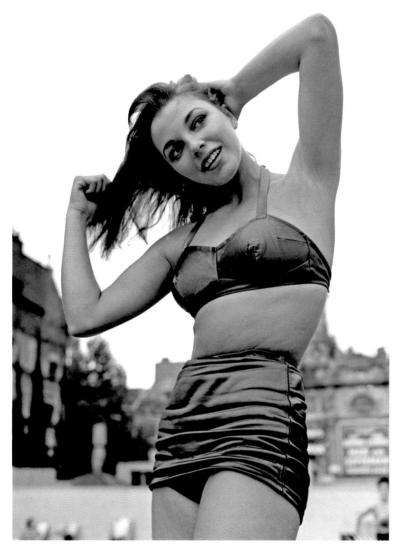

Actress Joan Collins prepares for filming at the Endell Street Baths in Holborn, London.
17th September, 1951

Actress Elizabeth Taylor arrives at the premiere of *The Lady With The Lamp* at Leicester Square's Warner Theatre, London.
22nd September, 1951

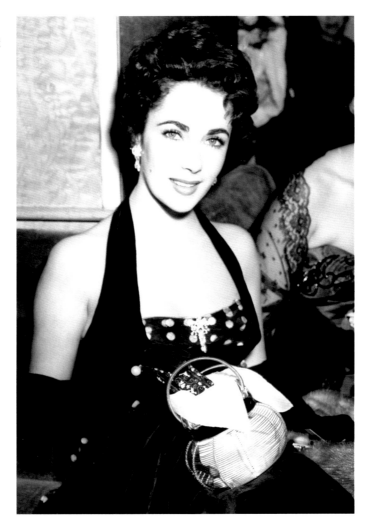

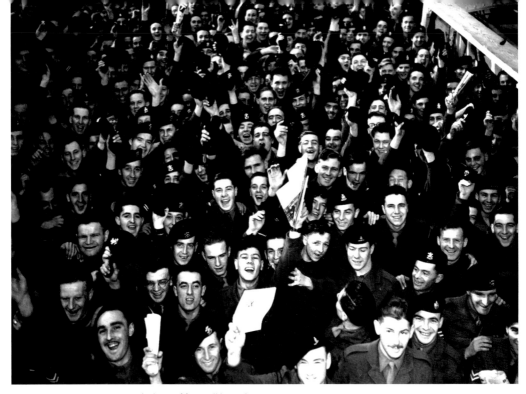

A cheer of farewell issued from hundreds of throats aboard the troopship *Empire Fowey* before she sailed from Southampton. Mostly National Servicemen, these members of the 1st Bn. Welch Regiment are on their way to join UN forces in Korea.

10th October, 1951

Princess Elizabeth began standing in for her father, King George VI on official duties as his health deteriorated. The princess's first visit to Canada had been delayed when the king's heath took a turn for the worse. Instead of arriving by ship, she and the Duke of Edinburgh arrived by plane, the first for a royal visit. All of the planned events on their 33-day trip across Canada were put back a week. Toronto was reported to be preparing for the *"worst traffic tangle in history"* when the princess arrived. Here she and the Duke of Edinburgh travel in an open Cadillac on their drive through Riverdale Park in Toronto.

18th October, 1951

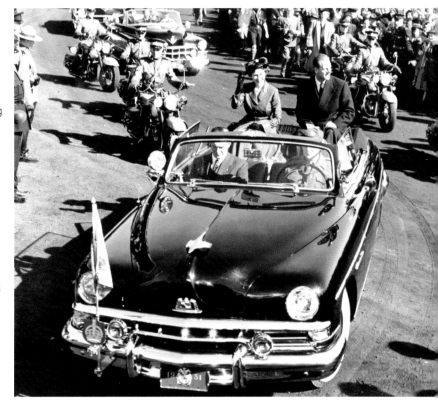

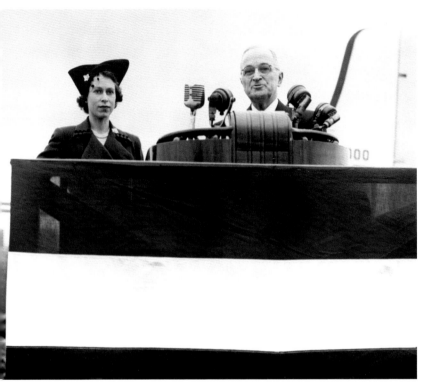

Standing in for her father on an official visit to the USA, Princess Elizabeth met President of the United States, Harry S. Truman in Washington, DC, after her Canadian tour. On the trip, her private secretary, Martin Charteris, carried a draft accession declaration for use in the event that the king died while she was away.

4th November, 1951

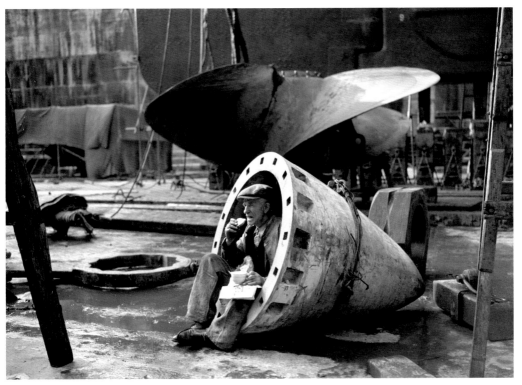

Boiler-maker Mr P. Sharp takes a break seated in the hollow, streamlined propellor cone during the annual overhaul of the liner the *Queen Mary* at Southampton.

23rd November, 1951

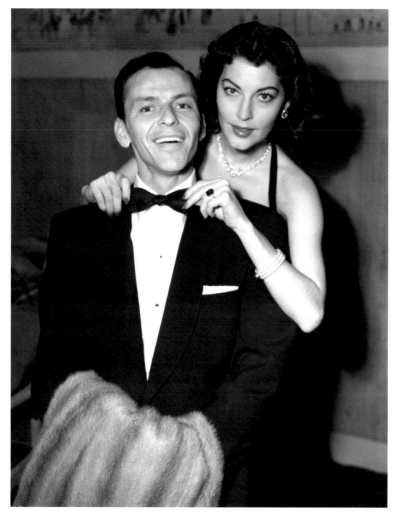

Ava Gardner straightens her husband Frank Sinatra's tie before they leave the Washington Hotel, Mayfair, London, for the Midnight Matinee at the London Coliseum.

10th December, 1951

Julie Andrews, at 16
London's youngest Principal
Girl, during the dress
rehearsal of Emile Littler's
pantomime *Aladdin* at the
London Casino.
14th December, 1951

Captain M.G. Harvey, MC (C) and Privates Shiers (L) and
Rudge (R) on arrival at Southampton with 1st Battalion, the
Gloucestershire Regiment, 'the Glorious Glosters'. During
the Korean War, Chinese forces isolated the battalion from
the rest of its brigade on the infamous 'Hill 235' during the
Battle of the Imjin River. The majority were captured, but
some, under Harvey, escaped to friendly lines.
21st December, 1951

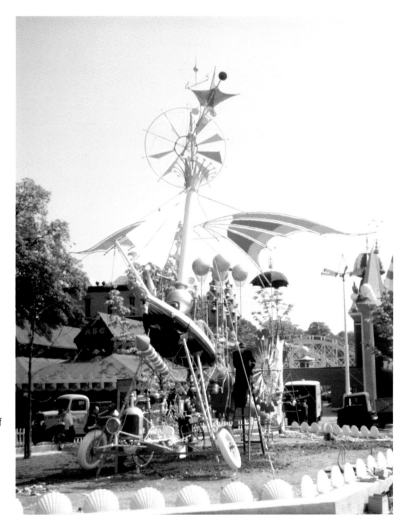

Astro Terra Mare, a fantasy 'Travel Machine', by English cartoonist and constructor of whimsical kinetic sculpture, Frederick Rowland Emett, was a popular display at the Pleasure Gardens in Battersea Park, during the Festival of Britain.
1st January, 1952

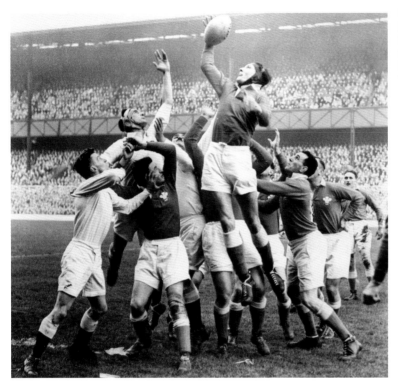

Wales' Roy John wins the ball at a line out during the England v Wales rugby union match in the Five Nations Championship.
19th January, 1952

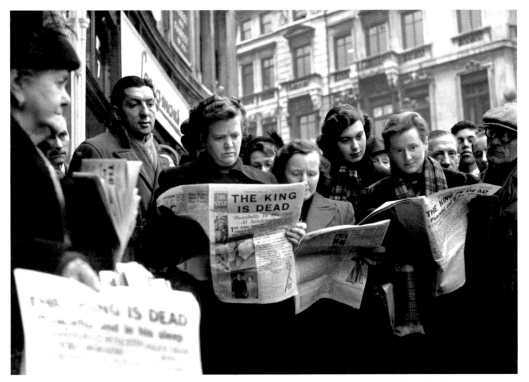

Lunch time crowds in Ludgate Circus, London learn the news of the death of King George VI, who died from a coronary thrombosis in his sleep at Sandringham House in Norfolk, at the age of 56. The stress of the Second World War had taken its toll on the king's health, exacerbated by his heavy smoking and eventual development of lung cancer, among other ailments including arteriosclerosis.

6th February, 1952

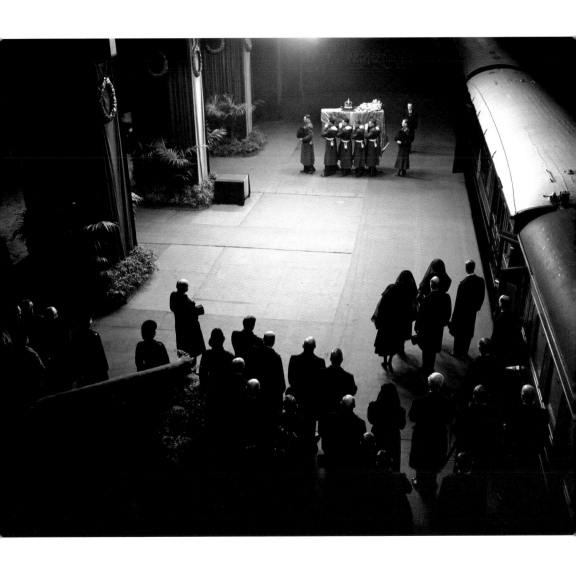

Facing page: King George VI returns to his capital from Sandringham to lie in state in Westminster Hall until his funeral. The draped coffin is carried from the train at Kings Cross in London.
11th February, 1952

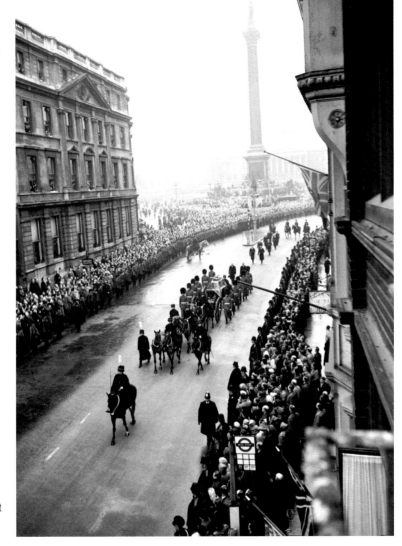

King George VI's body passes down Whitehall in a cortege, to be laid in state at Westminster Hall.
11th February, 1952

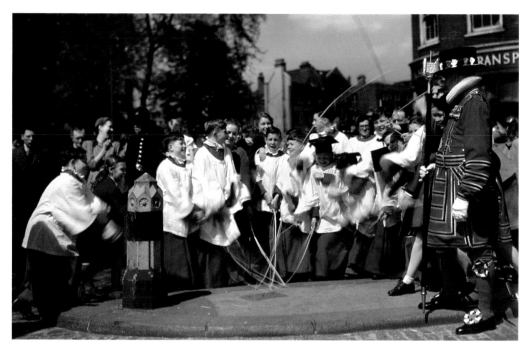

Choir boys 'beating the bounds' at the Tower of London. This ancient custom is still observed in some English and Welsh parishes, when the priest, churchwardens and parochial officials headed a crowd of boys who, armed with boughs of birch or willow, beat the parish boundary markers with them to ensure that witnesses to the boundaries should survive. In past times the boys were themselves whipped or violently bumped on the boundary-stones to make them remember.

22nd February, 1952

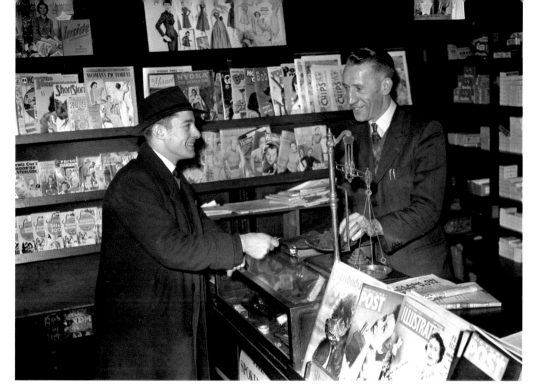

Football referee Alf Bond serves a customer in his newsagents shop in Fulham, London. Former right-half for Danes Athletic in the South-West District League, of which he was Vice-President, Bond lost his right arm at the age of 19 when working in a rubber factory. He controlled his first league game in 1948 – a Third Division (South) match – and officiated at the 1954 FA Amateur Cup Final at Wembley between Bishop Auckland and Crook Town, and also refereed four international matches. At the pinnacle of his career, he refereed the 1956 FA Cup Final.
27th February, 1952

TV's elegant comedian Terry-Thomas, famous for his distinctive sartorial style and gap-toothed smile, returns at Southampton docks from a holiday in Madeira, sporting a cap and extended cigarette holder.
25th March, 1952

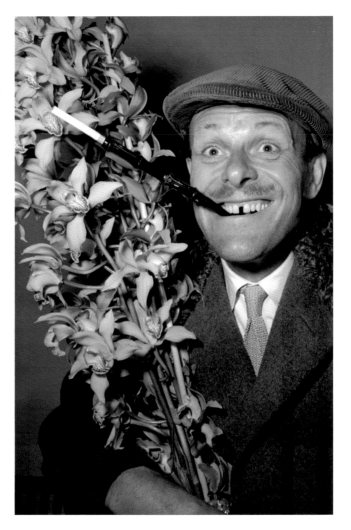

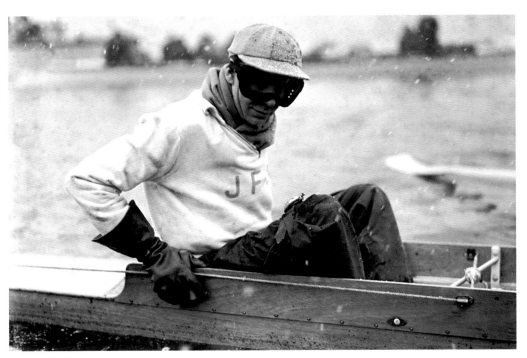

Cambridge University cox
J.F.K. Hinde, fully kitted-out
against the foul weather with
heavy-duty goggles and
leather gloves, before the
annual rowing race against
the Oxford University team.
29th March, 1952

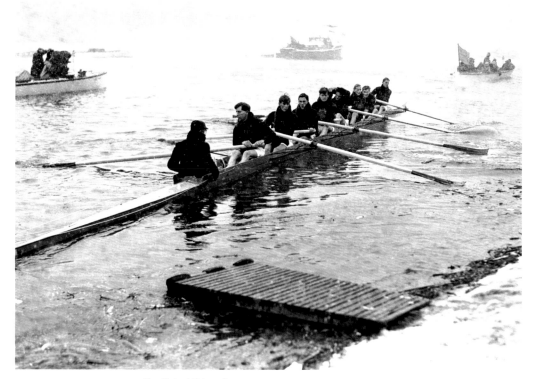

The Oxford University crew row out in a blizzard to the starting point of the 98th Boat Race. They beat the Cambridge crew 'by a canvas' (the tapering covered part at the end of a racing boat).

29th March, 1952

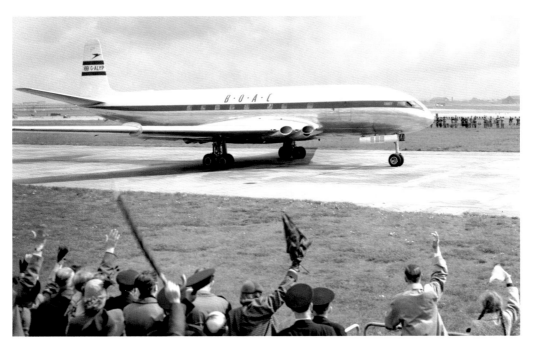

The world's first regular jetliner service was inaugurated on 2nd May, 1952 when a 36-seat de Havilland Comet of British Overseas Airways (BOAC) took off from London's Heathrow Airport on a flight to Johannesburg, South Africa. The Comet was the world's first commercial jet airliner, having first taken to the air in 1949.
2nd May, 1952

Apprentice cooper Albert Stokes from Battersea, South London, is initiated after passing his apprenticeship at the Stag Brewery in Pimlico.
9th May, 1952

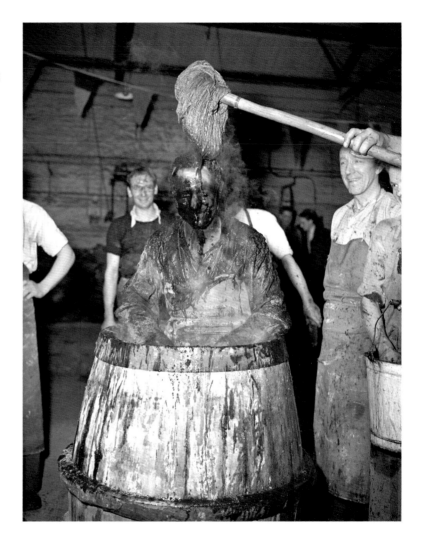

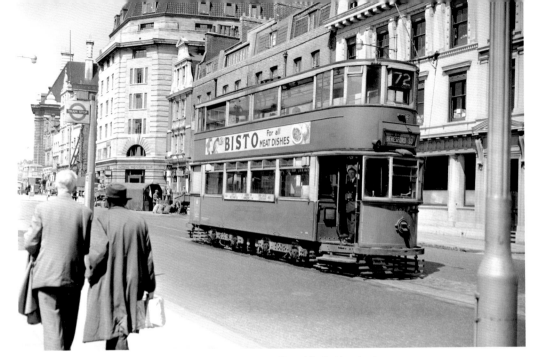

One of the last London trams
in Westminster Bridge Road.
29th May, 1952

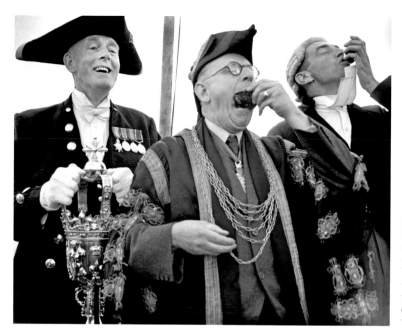

Oyster fishing starts at Brightlingsea, Essex. In an age-old custom performed on board the smack *Native*, The Mayor of Colchester, Counciller C. Lee, samples the first oyster from the first dredge of the season.

7th June, 1952

In the Ramsgate Sands Regatta Trophy, Gates captain J. Briscoe and his team celebrate victory over the Rams with a pair of kippers each.
21st July, 1952

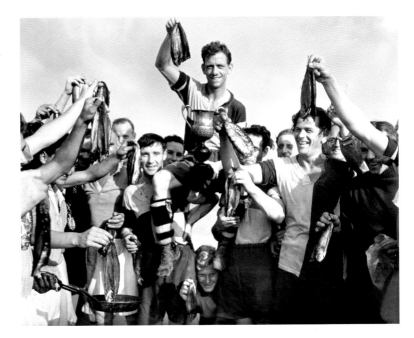

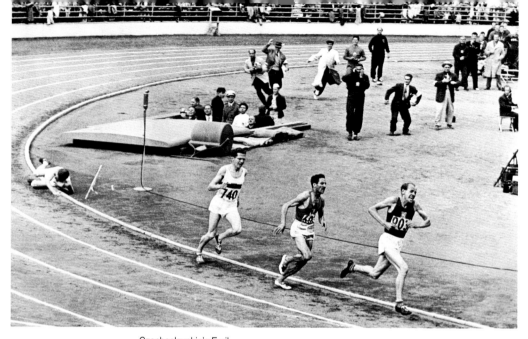

Czechoslovakia's Emil Zatopek (R) sprints to gold, beating France's Alain Mimoun (second R, silver) and Germany's Herbert Schade (third R, bronze), as Great Britain's Chris Chataway (L) falls in the Men's 5,000m final at the Helsinki Olympic Games.
22nd July, 1952

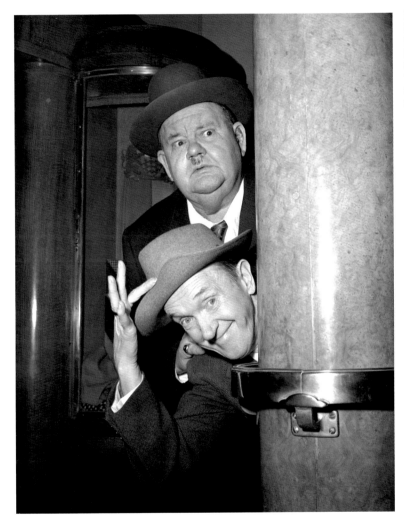

Film comedians Stan Laurel (bottom) and Oliver Hardy aboard the *Queen Mary* at Southampton. The pair starred together in almost 100 films between 1927 and 1952.

7th August, 1952

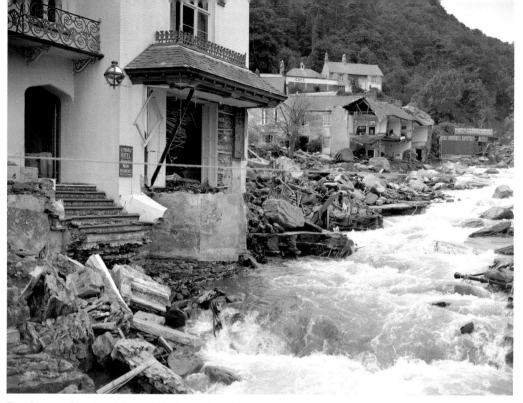

The aftermath of the devastating flood that swept through the resorts of Lynmouth and Lynton in North Devon. On 15th and 16th August, a storm of tropical intensity broke over south-west England, depositing nine inches of rain in 24 hours. Debris-laden floodwaters cascaded down the northern escarpment of the Exmoor, destroying or damaging more than 100 buildings, 28 bridges, and washing 38 cars out to sea. Thirty-four people died and 420 were made homeless.

17th August, 1952

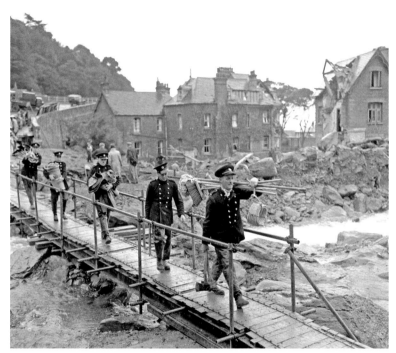

In Lynmouth, police, troops, firemen and salvage workers begin the grim task of clearing debris and searching for bodies after the tidal wave. Here firemen arrive, via a temporary bridge, to help.

19th August, 1952

Actress Dinah Sheridan with canine friend Susie, appearing in the British comedy film that was originally entitled *Old Crocks*, but later known as the classic *Genevieve*. Produced and directed by Henry Cornelius, it was written by William Rose, and starred John Gregson, Dinah Sheridan, Kenneth More and Kay Kendall as two couples in a vintage automobile rally.

23rd September, 1952

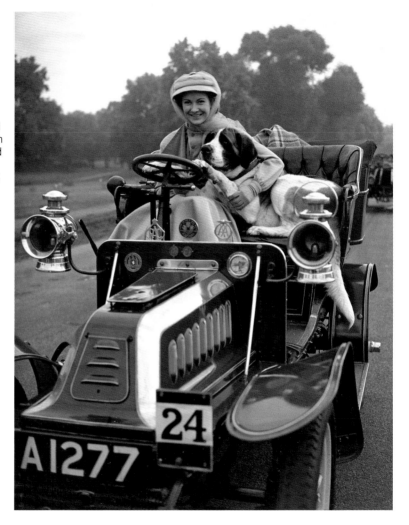

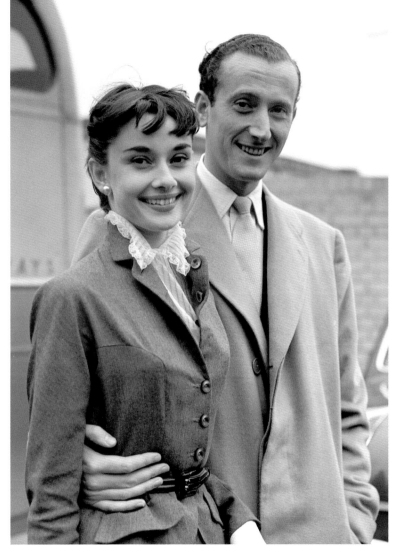

Reunited at Northolt Airport were film star Audrey Hepburn and her fiancé, the industrialist James Hanson, who she was to have married that day. However, despite having her wedding dress fitted and the date set, she called off the forthcoming marriage siting the conflicting demands of their careers, which she believed would keep them apart for much of the time, saying *"When I get married, I want to be really married."*
30th September, 1952

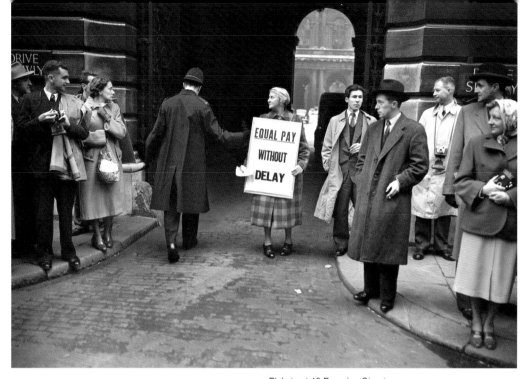

Pickets at 10 Downing Street
in London demanding equal
pay for women.
14th October, 1952

Charlie Chaplin and his wife, Oona, preparing to leave Heathrow Airport for Paris. It had just been announced by US Attorney-General James P. McGranery in Washington that Chaplin – under investigation by the FBI and the House Un-American Activities Commission for his left-wing leanings, and refused re-entry to the USA the previous month – would be allowed to re-enter America only if he could prove his 'worth and right'. He chose not to.

29th October, 1952

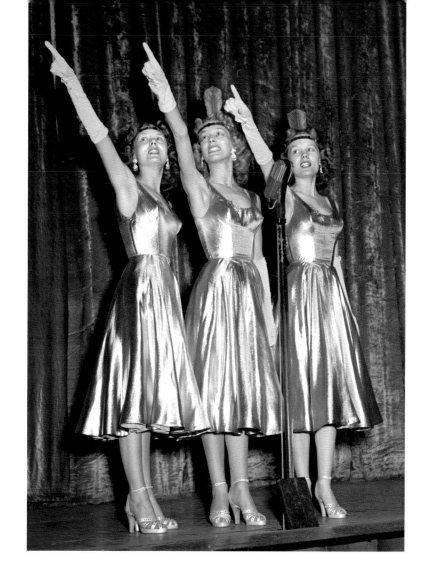

The Beverley Sisters at a rehearsal for the Royal Variety Performance.
3rd November, 1952

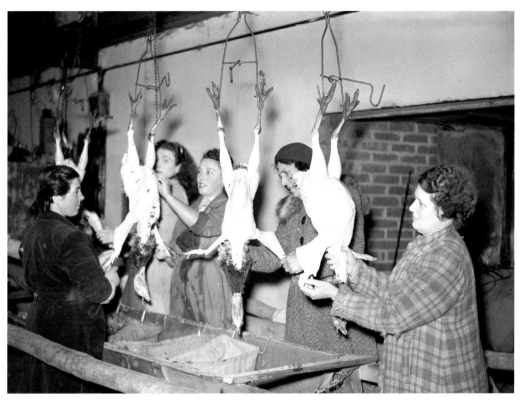

Women plucking turkeys
at High Tilt Farm,
Cranbrook, Kent.
12th December, 1952

Showjumper, and later author, Pat Smythe with one of her horses.
1st January, 1953

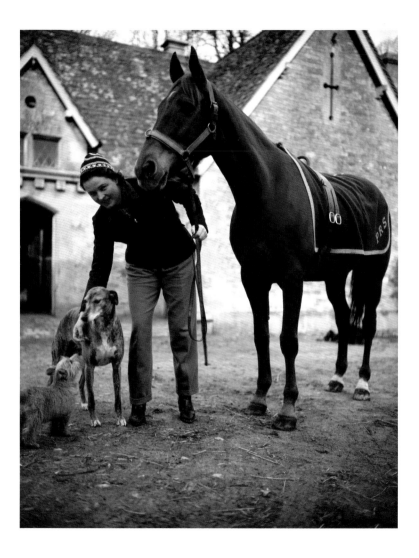

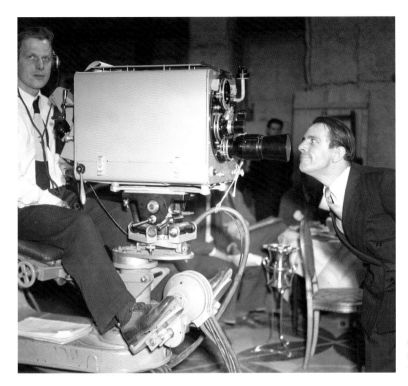

Comedian Norman Wisdom
stares down a camera.
1st January, 1953

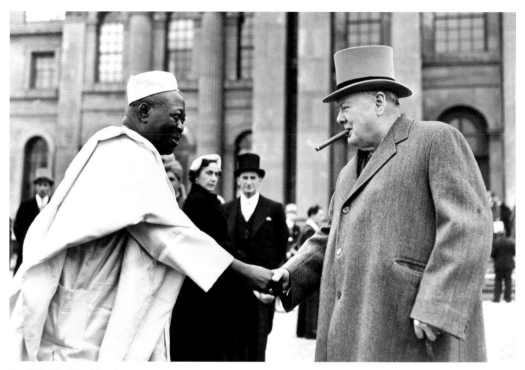

The Oni of Ife, Oba Adesoji
Aderemi II, shakes hands
with British Prime Minister
Winston Churchill at
Blenheim Palace.
1st January, 1953

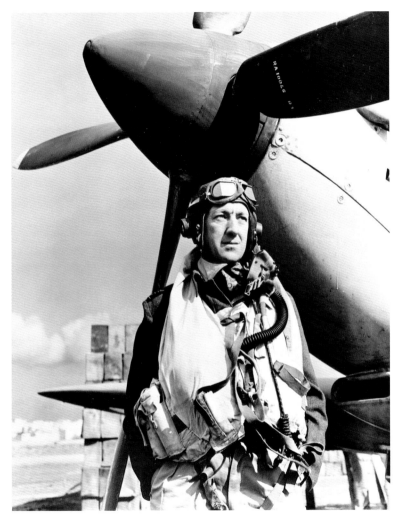

Actor Alec Guinness stands in front of a Mk 9 Spitfire during filming of the film *The Malta Story*, in which he played the role of Pilot Officer Peter Ross, a character loosely based on real-life RAF hero Adrian Warburton, a fearless reconnaissance pilot. Warburton disappeared on 12th April, 1944, while flying a photographic mission over Germany. His remains and aircraft were discovered in 2002, buried deep in a field near the village of Egling an der Paar, 34 miles south-west of Munich.

12th January, 1953

Florence Mynar (L) and
Doris Howson practice
their skills for the annual
Transatlantic Pancake
Trophy Race in Olney,
Buckinghamshire.
31st January, 1953

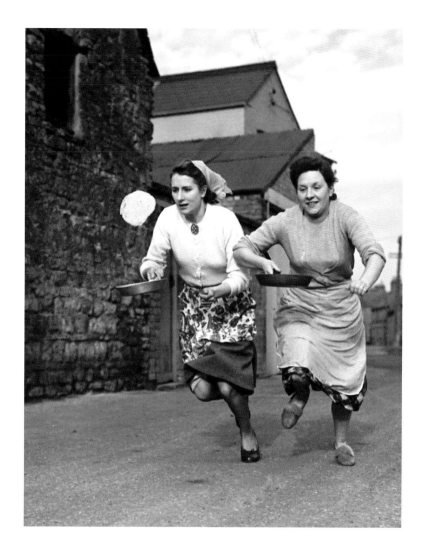

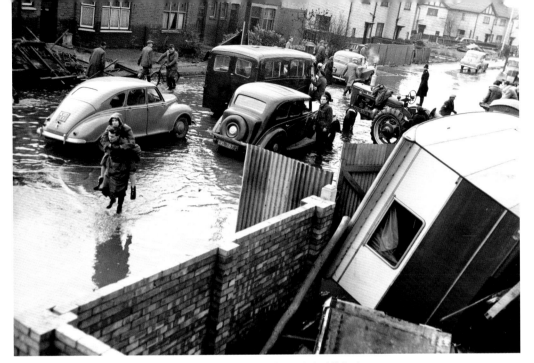

Chaos in the Wisbech
Road area, worst stricken
flood spot in King's Lynn,
Norfolk. The town was hit
in widespread flooding that
affected most of Britain's
eastern seaboard.
1st February, 1953

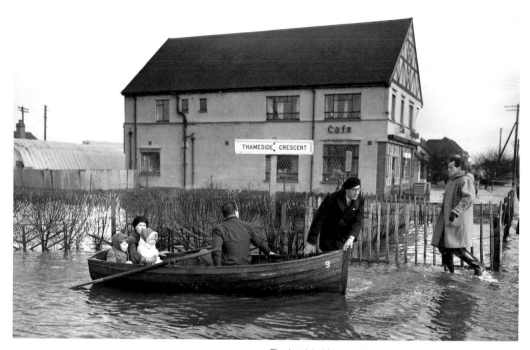

The last inhabitants to be evacuated by police, troops and other services from Canvey Island in Essex, where more than 100 people died in the flood disaster.
2nd February, 1953

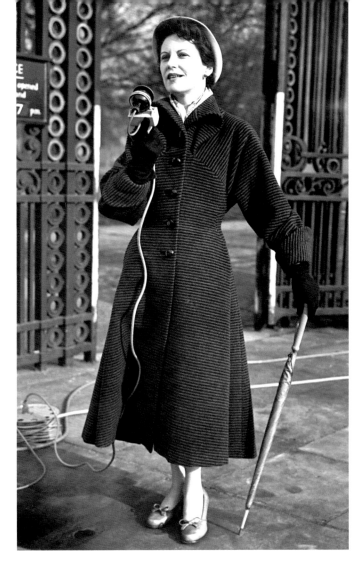

Microphone and umbrella in hand, Manchester-born broadcaster Jessica Dunning makes an outside broadcast (from a position near Buckingham Palace) in an audition for commentators for the forthcoming Coronation. It was thought that women may be better able to handle some aspects of the day's ceremonies.

21st February, 1953

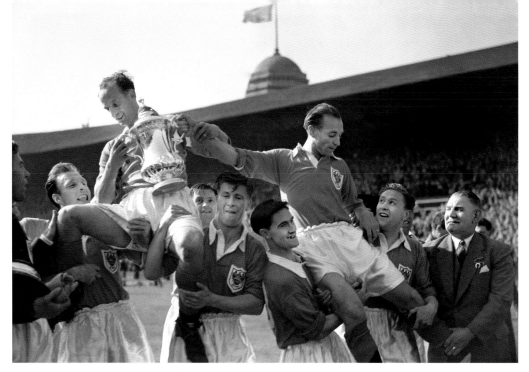

Blackpool captain Harry
Johnston (top, L) holds
the FA Cup aloft after his
team came back from 3–1
down to win 4–3 against
Bolton Wanderers, thanks
to inspired performances
from Stanley Matthews
(top, R), hat trick hero Stan
Mortensen (R) and winning
goalscorer Bill Perry (third L).
2nd May, 1953

Elegant Belgian-born actress Audrey Hepburn arrives at Heathrow Airport from New York, shortly before the release of the film *Roman Holiday*, in which she starred alongside Gregory Peck and for which she subsequently won the Academy Award for Best Actress.
21st May, 1953

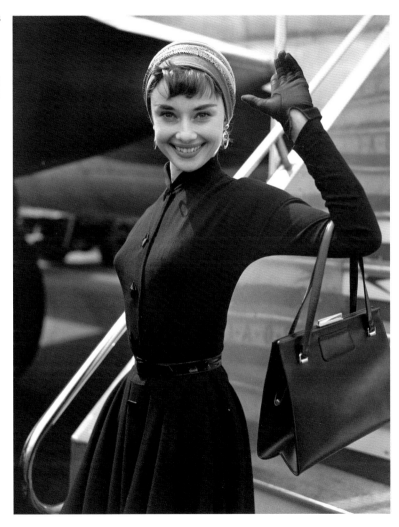

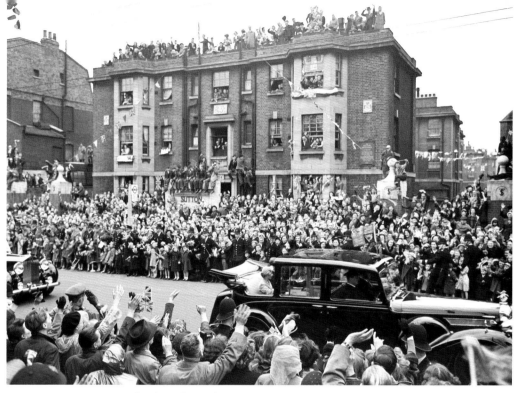

Practice makes perfect.
Queen Elizabeth II rehearses
for the Coronation.
30th May, 1953

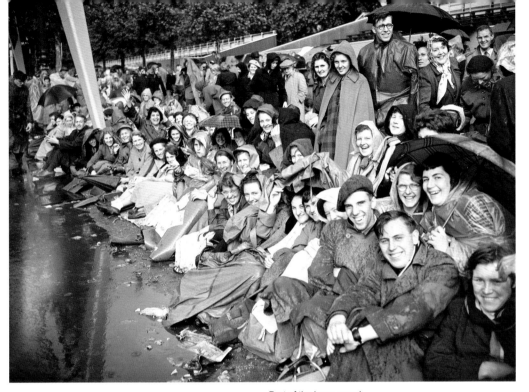

Part of the large crowd
that lined the Mall patiently
before the Coronation
of Queen Elizabeth II.
1st June, 1953

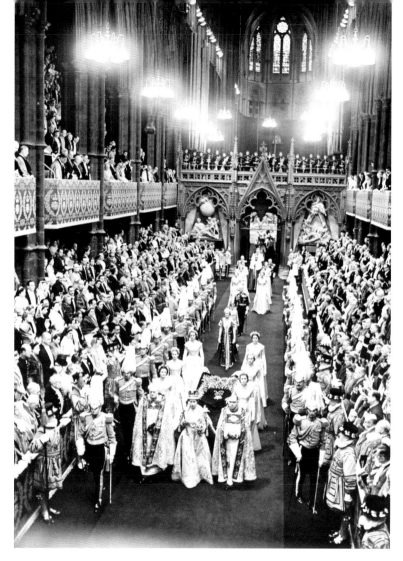

Queen Elizabeth II walking through Westminster Abbey escorted by the Bishop of Durham, Michael Ramsay (L) and the Bishop of Bath and Wells, Harold Bradfield, after her Coronation.
2nd June, 1953

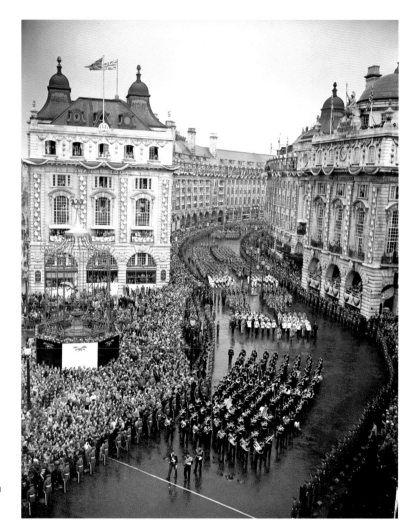

The Royal procession passing through Piccadilly Circus after the Coronation of Queen Elizabeth II.
2nd June, 1953

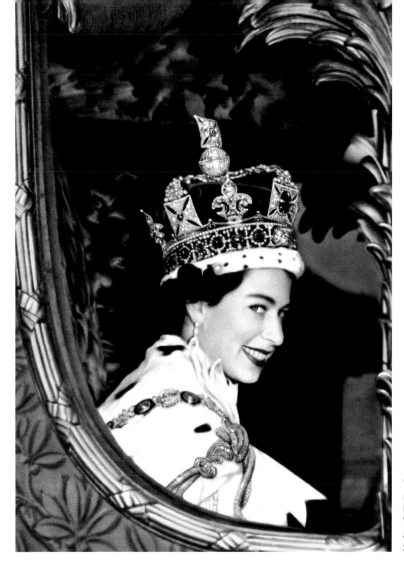

The Queen gives a wide smile for the crowd from her carriage as she leaves Westminster Abbey, London after her Coronation.
2nd June, 1953

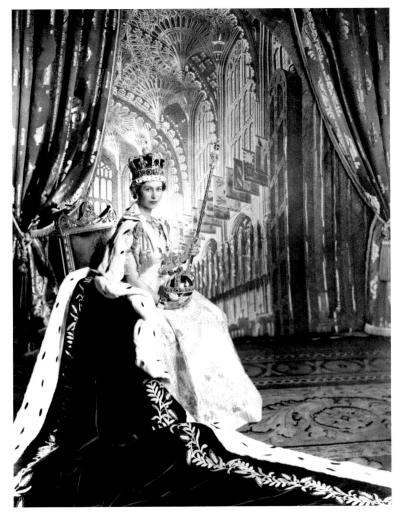

A portrait of Queen Elizabeth II wearing the Imperial State Crown, taken in Buckingham Palace after her Coronation at Westminster Abbey.
2nd June, 1953

Flamboyant Bookmaker
Johnny of Bromley with
a patriotic display in the
Coronation year.
6th June, 1953

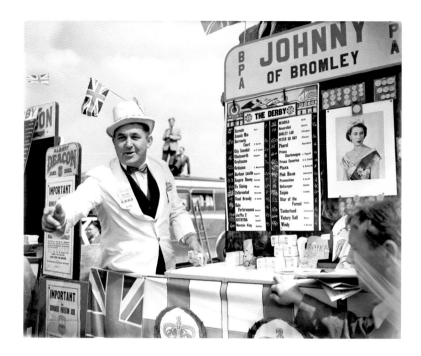

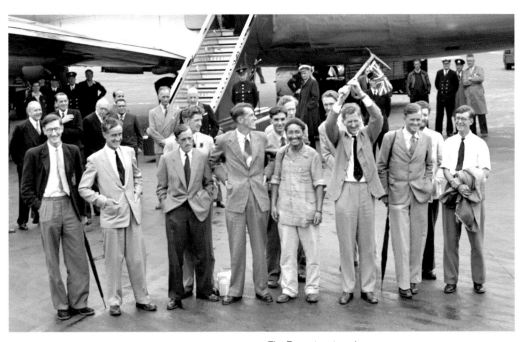

The Everest party arrive at Heathrow Airport to a rapturous welcome, after they had been the first to reach the summit of Mount Everest. Front row, L–R: G.C. Band, Major C.G. Wylie, A. Gregory, Edmund Hillary, Sherpa Tenzing Norgay, Colonel John Hunt, Dr Charles Evans and Mike Westmacott.
3rd July, 1953

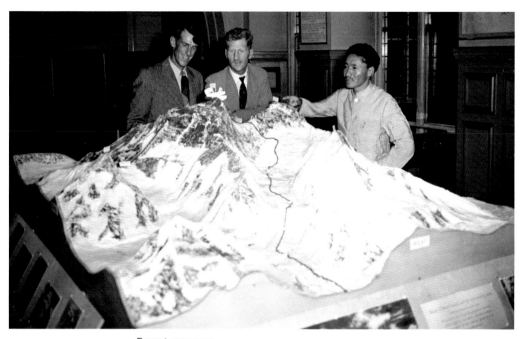

Everest conquerors
Edmund Hillary (L) with
Sherpa Tensing Norgay
(R) and Colonel John Hunt,
the expedition leader,
study a model of the
Himalayas during a press
conference held at the Royal
Geographical Society in
Kensington, London.
3rd July, 1953

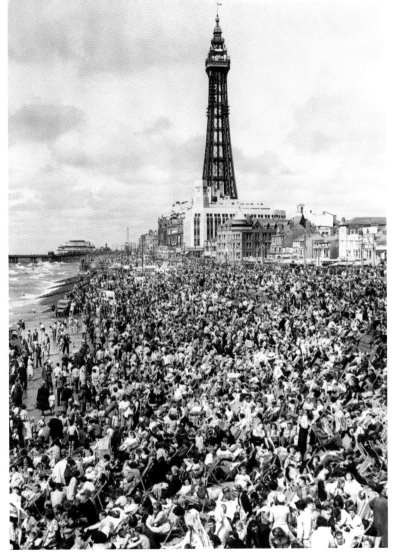

Bank Holiday crowds pack
the beach at Blackpool.
2nd August, 1953

Britain's Randolph 'Randy' Turpin (L) from Leamington Spa, Warwickshire, and France's Charles Humez trade punches during their fight at White City, London, for the vacant World Middleweight Title. Turpin, a former champion, won on points after 15 rounds. After he had beaten American Sugar Ray Robinson for the world title in July 1951, Turpin, the 'Leamington Larruper' became a national hero, only to lose his crown to Robinson just two months later. Turpin never regained his form and, after being bankrupted in 1966, committed suicide by shooting himself.

9th June, 1953

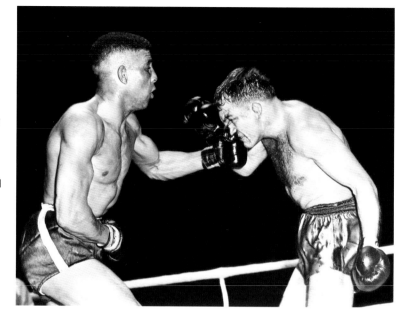

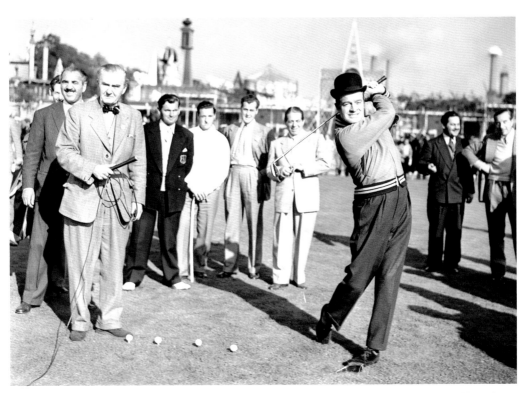

Comedian Bob Hope tries
playing a shot in alternative
golfing headgear.
24th September, 1953

Manned by an Army driver, a tanker carrying fuel oil leaves a depot in Fulham, London. Drivers from all three services were moved to depots to restore the distribution of petrol and oil, interrupted by a strike of tanker drivers.

24th October, 1953

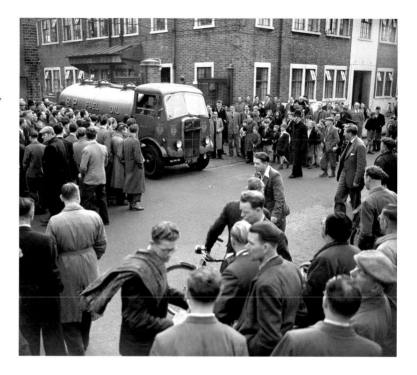

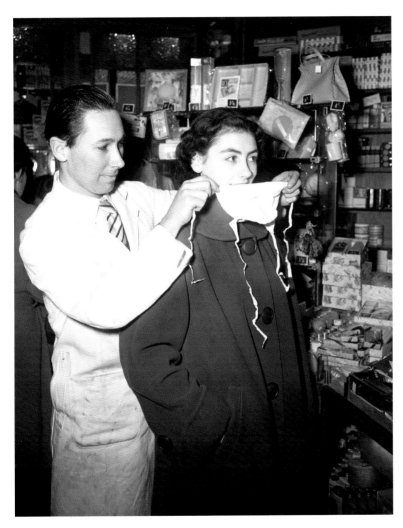

Sheila Glibbery was determined to suffer no ill effects from smog on her journey home to Essex. To make certain, she bought a smog mask – here she is seen having it fitted in a chemists' shop in Charing Cross, London.

17th November, 1953

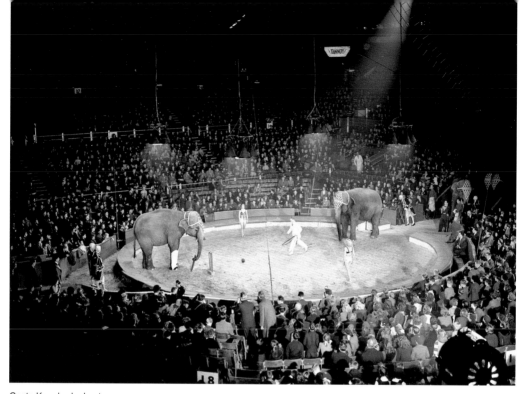

Gosta Krum's elephants
perform at Olympia with
Bertram Mills' Circus.
17th December, 1953

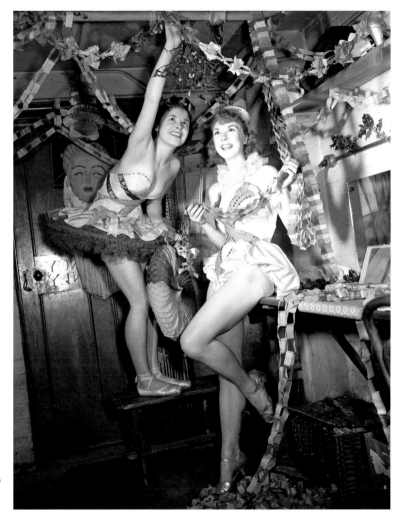

Windmill Girls Rosemary Phillips and Kathleen Cooper putting up Christmas decorations in their dressing room at the Windmill Theatre in London.

18th December, 1953

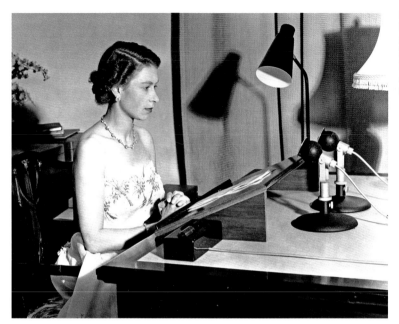

Queen Elizabeth II broadcasts her Christmas address to the peoples of the British Commonwealth from Government House, Auckland, New Zealand.
31st December, 1953

Facing page: Olde Worlde charm. A shopkeeper leans over the stable door to hand a small girl a bunch of flowers in the North Wiltshire village of Lacock, near Chippenham in Wiltshire.
1st January, 1954

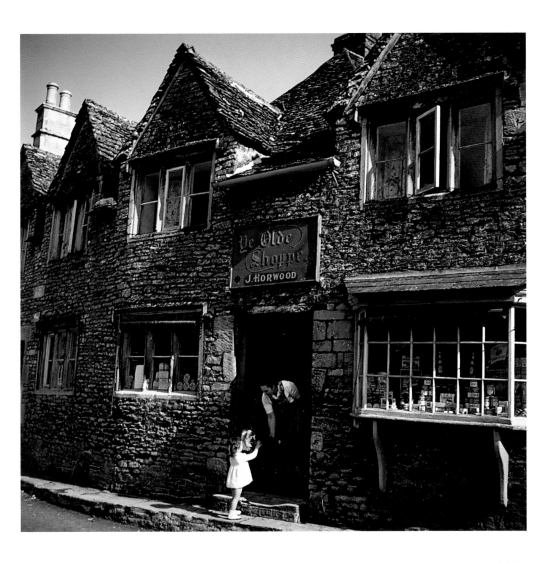

The clipper *Cutty Sark* is towed into East India Dock, London, for reconditioning and rerigging before taking up her permanent berth at Greenwich.

18th February, 1954

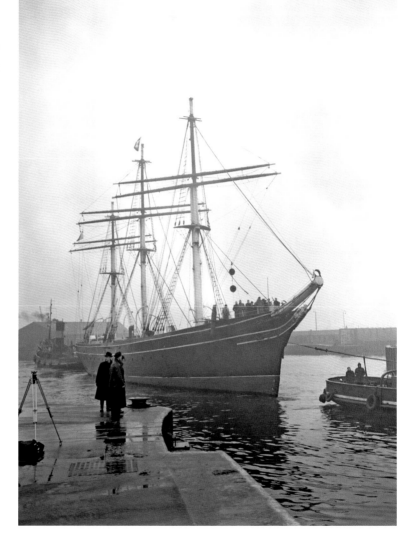

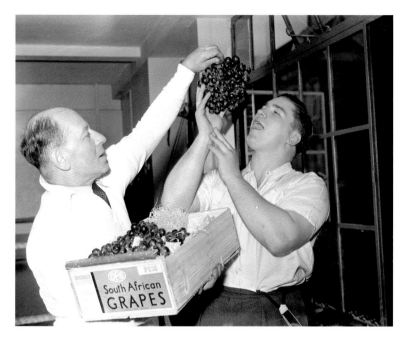

Trainer Joe Bloom (L)
teases light heavyweight
boxer Don Cockell with
a bunch of grapes. The
boxer had experienced
difficulty in making the
weight for light heavyweight
fights and subsequently
decided to fight as a
heavyweight.
5th March, 1954

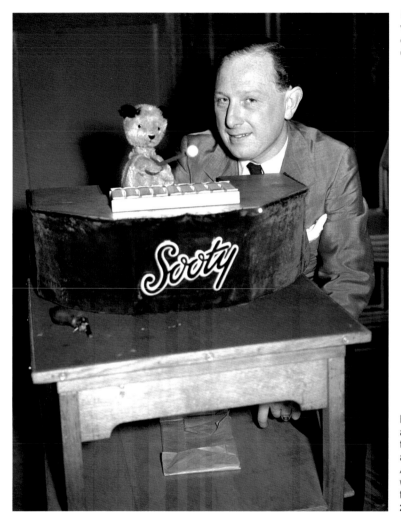

Helping hand. Harry Corbett with his furry chum, the TV entertainer Sooty.
6th March, 1954

Facing page: The Queen and Duke of Edinburgh with the ship's company during an official visit to HMAS *Australia*. The Royal couple went aboard during their visit to Cairns, Queensland.
20th March, 1954

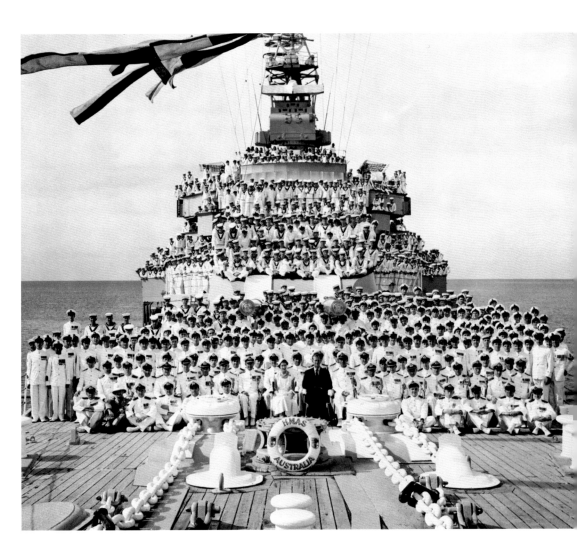

An RAC road patrolman
stands next to his Norton
motorcycle combination.
25th March, 1954

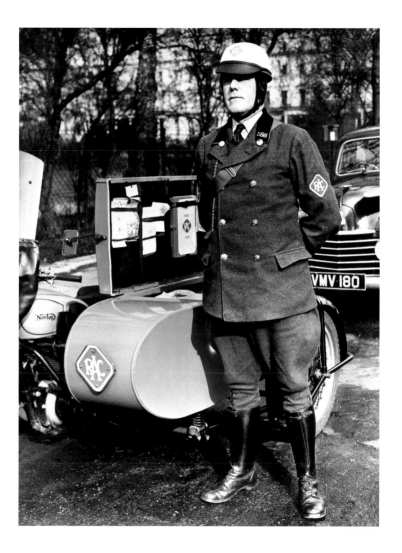

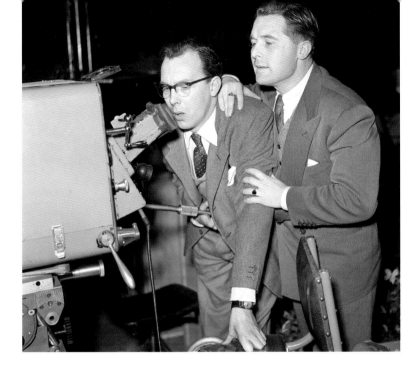

Comedians Eric Morecambe
(L) and Ernie Wise take
a look at the view from
the other side of the camera.
30th March, 1954

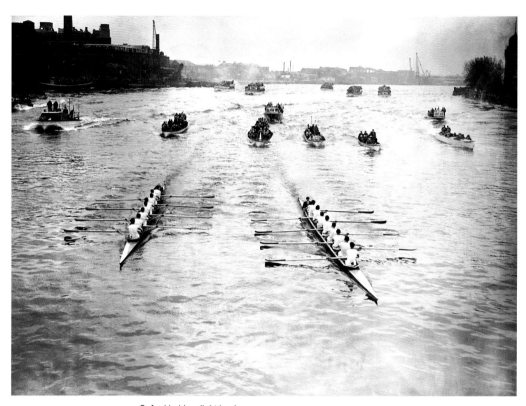

Oxford hold a slight lead over Cambridge as the crews approach Hammersmith Bridge during the milestone 100th Boat Race. Oxford would go on to win the race in rough conditions on the River Thames.

3rd April, 1954

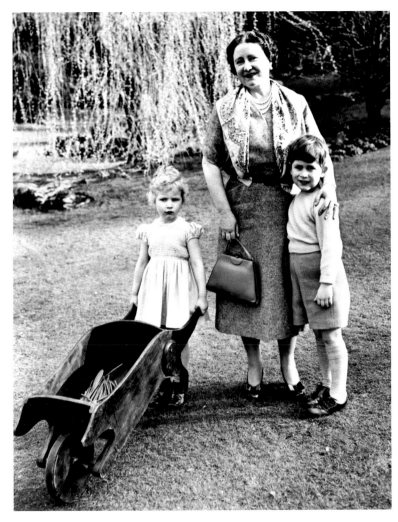

Princess Anne wheels her barrow and Prince Charles stands with his grandmother, the Queen Mother, in the grounds of the Royal Lodge, Windsor, Berkshire.

22nd April, 1954

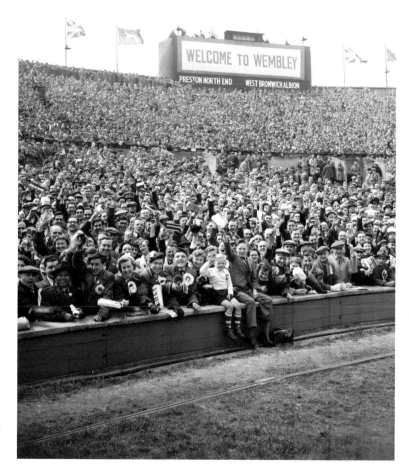

Team supporters pack the terraces at Wembley Stadium as they wait for the FA Cup Final to kick-off.
1st May, 1954

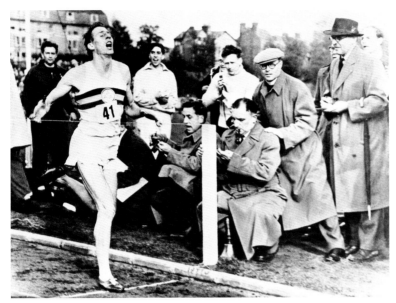

Medical student Roger Bannister hits the tape at an athletics meeting in Oxford and the world's first four minute mile has been run – in three minutes, fifty-nine-point-four seconds.

6th May, 1954

The Prince of Wales with his sister, Princess Anne, meeting one of Gibraltar's famous Barbary apes.
11th May, 1954

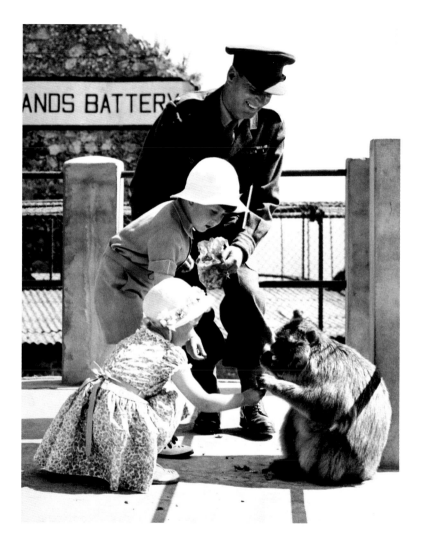

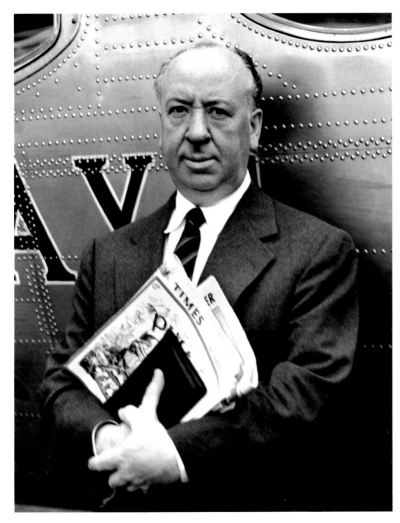

British-born Hollywood film director Alfred Hitchcock pictured at Heathrow Airport, as he was about to board a BEA plane for Paris.

13th May, 1954

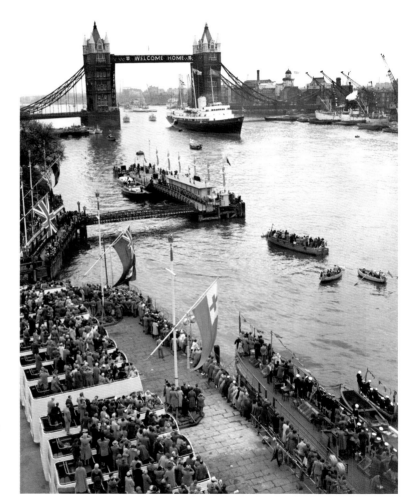

Tower Bridge wears a 'Welcome Home' sign, as the Royal Yacht *Britannia* enters the Pool of London at the end of a 50,000 mile journey for the Queen and Duke of Edinburgh, whom she had brought home from the tour of the Commonwealth.

15th May, 1954

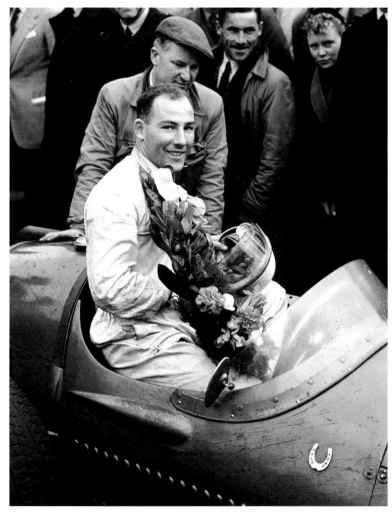

Stirling Moss sitting in his Maserati after winning the Aintree 200 race, at the Daily Telegraph International Meeting, the first to be held at the new track built beside the famous Grand National horse racing course.

30th May, 1954

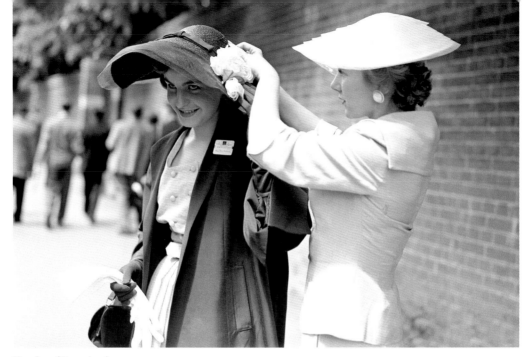

Miss Sara Skinner has her
hat adjusted by Mrs Richard
Brew at Royal Ascot.
15th June, 1954

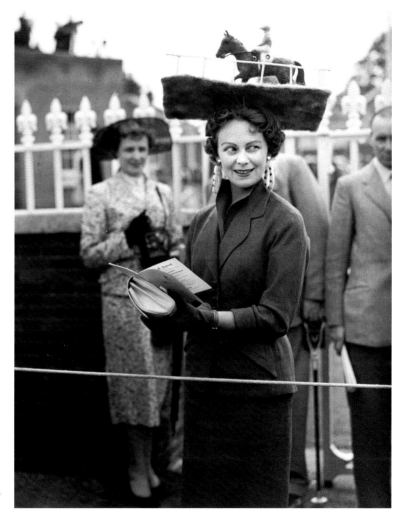

Mrs Netta Tudor at Royal
Ascot, wearing a hat
featuring a model racehorse.
15th June, 1954

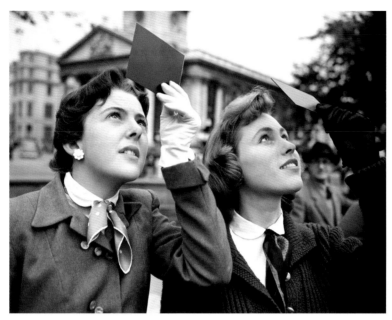

Millions witnessed a total
eclipse of the sun as the
moon cast its shadow from
America through Europe
and on to Asia. Watching
the eclipse through smoked
glass in Trafalgar Square,
London are Barbara
Stanley and Maureen
Gayer. They saw three-
quarters of the sun's disc
obscured by the moon.
30th June, 1954

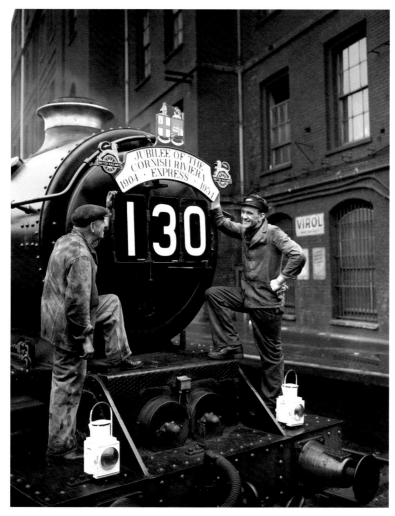

A special headboard on locomotive No 130 commemorates the 50th anniversary of the *Cornish Riviera Express*, Western Region's crack train, at Paddington Station, London before beginning its 246 mile run to Penzance, Cornwall.

1st July, 1954

Roger Bannister, the first man to crack the four-minute mile, easily retains his Mile title in the Amateur Athletic Association championships at the White City Stadium, London.
10th July, 1954

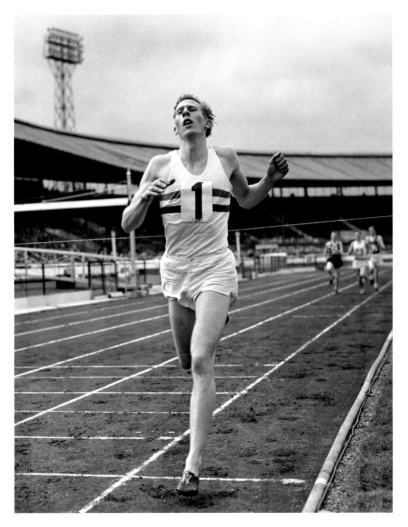

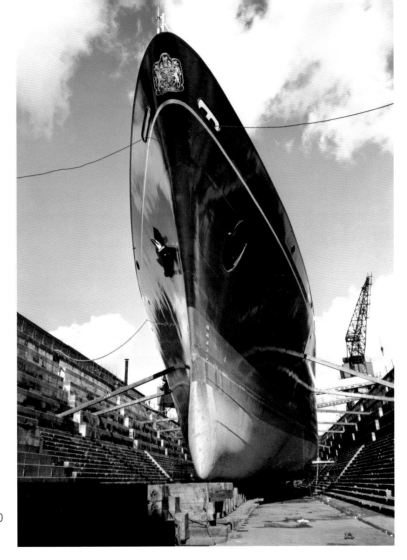

The Royal Yacht *Britannia* in Portsmouth dry dock for overhaul following its 50,000 mile Commonwealth tour.
29th September, 1954

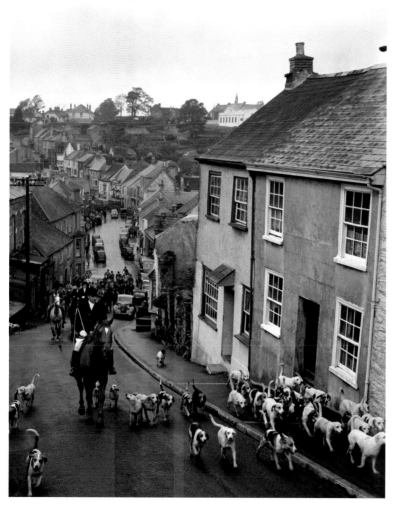

The Modbury Harriers move off after the opening Meet in the village of Modbury, South Devon. Huntsman George Baskerville is leading the hounds.
16th October, 1954

Comedian Tony Hancock
during the recording of his
Hancock's Half Hour
radio show at the BBC.
1st November, 1954

American jazz singer Frankie Laine (R) with Al Lerner, pianist, composer and conductor (L) and British jazz guitarist and bandleader Vic Lewis, rehearsing at the BBC. Laine was in Britain to appear in the Royal Command Performance for Queen Elizabeth II, which he cited as one of the highlights of his career. He had become more popular in the United Kingdom than in the USA, and many of his hit records in the Britain were only minor hits in his native country. Laine remained far ahead of Elvis Presley as the most successful artist on the British charts.

2nd November, 1954

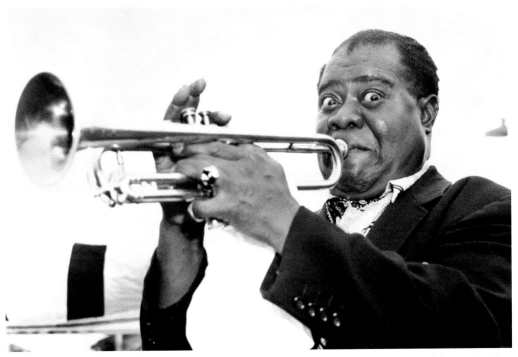

'Satchmo', the American jazz trumpeter and singer Louis Armstrong blows his horn for the crowd after a flight from San Francisco, USA on a visit to the UK.

4th November, 1954

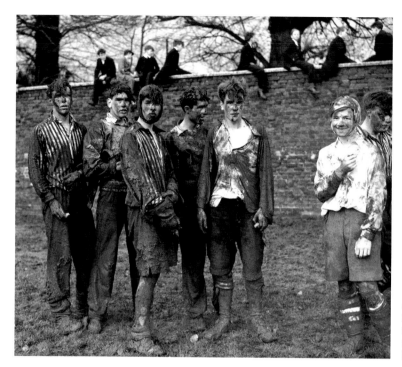

At Eton College, the mud-covered Collegers take a breather at half time during the Wall Game.
30th November, 1954

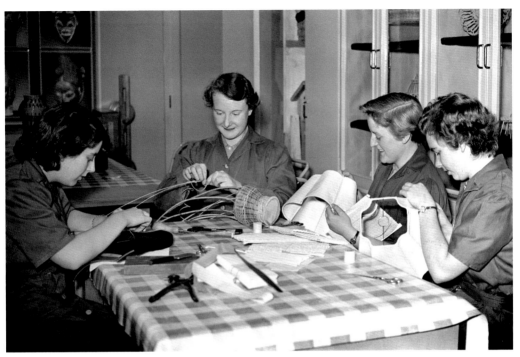

Basket weaving at the
Battersea Training College
of Domestic Science.
7th December, 1954

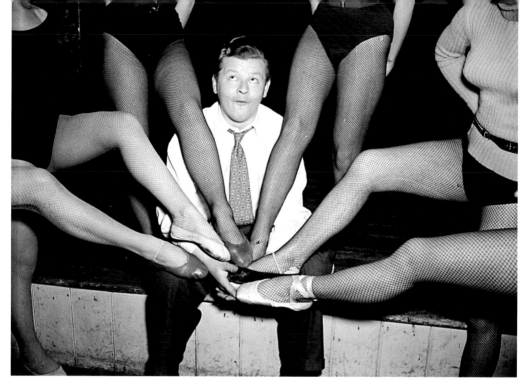

TV comedian Benny Hill
auditioning chorus girls for
his show *Benny's Merry-Go-Round*, in London.
2nd January, 1955

Facing page: Tending to the pigeons in a wintry Trafalgar
Square, London. Feeding the feral pigeons was a popular
activity, but their droppings disfigured stonework, and
the flock – at its peak estimated as 35,000 – became a
health hazard. In 2005, the sale of bird seed in the square
was stopped and measures introduced to discourage the
pigeons, including the use of trained birds of prey.
4th January, 1955

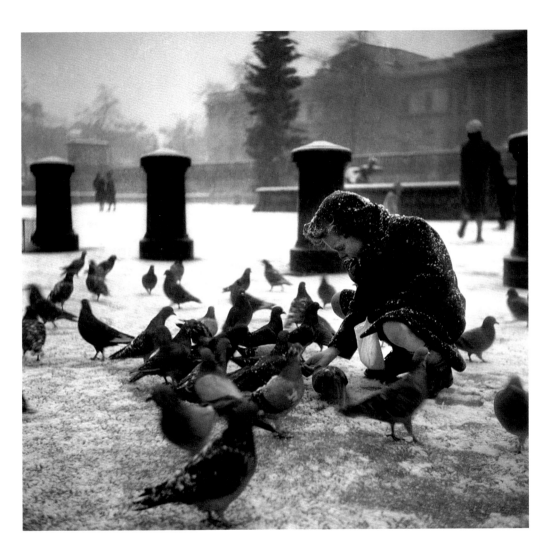

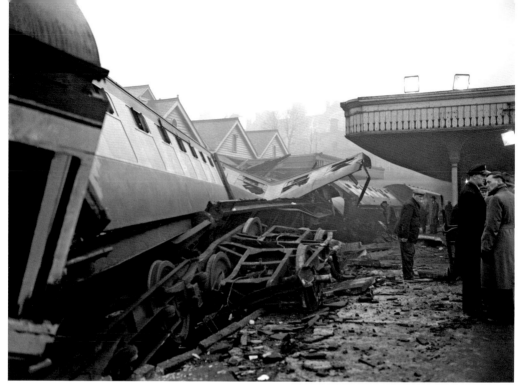

The platform at Sutton Coldfield station, West Midlands, where 15 people lost their lives and more than 40 were injured when the 12.15 train from York to Bristol became derailed while passing through the station. The train had been diverted from its usual route because of track repairs.
24th January, 1955

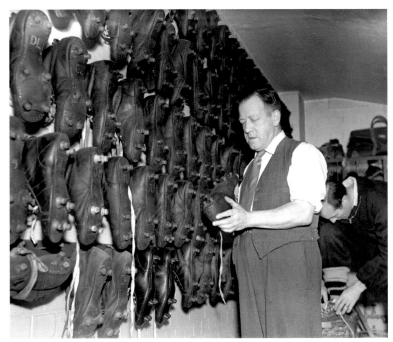

Arsenal's boot-room boy
Danny Cripps examines
footballer Tommy Lawton's
boots. Lancashire-born
Lawton retired from playing,
aged 35, at the end of the
1954–55 season, after a
20-year career. In 1952,
he had become player-
manager at Brentford but
with little success, and in
1953 moved to Arsenal for
£10,000, where he saw out
his playing career there.
In his two years with the
Gunners he scored 15 goals
in 38 matches, including one
in the Gunners' 1953 Charity
Shield win over Stanley
Matthews' Blackpool.
3rd February, 1955

L–R: Six-foot-four-inch Scot and Arsenal centre back Jim Fotheringham, and Welshmen Dave Bowen and Derek Tapscott work out in the gymnasium at the Highbury ground.
3rd February, 1955

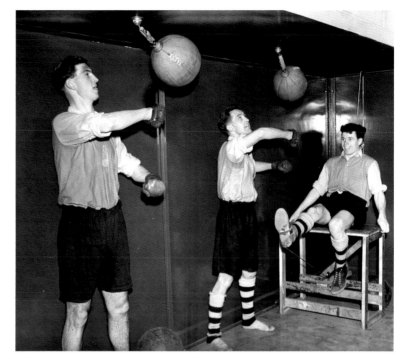

Childhood Innocence: Harry Corbett with his sons David (9) and Peter (6), and the irrepressible Sooty. Corbett had bought the original glove puppet to entertain his children from a novelty shop on Blackpool's North Pier. The pair soon achieved success and their own TV show. On Harry's retirement in 1976, Peter took on the mantle as Sooty's assistant, adopting the stage name Matthew Corbett.

8th February, 1955

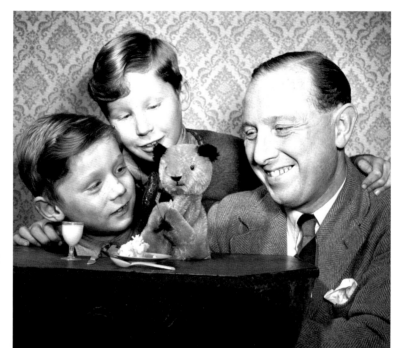

Actor Peter Ustinov
at London's Heathrow
Airport, on his way to Paris.
12th February, 1955

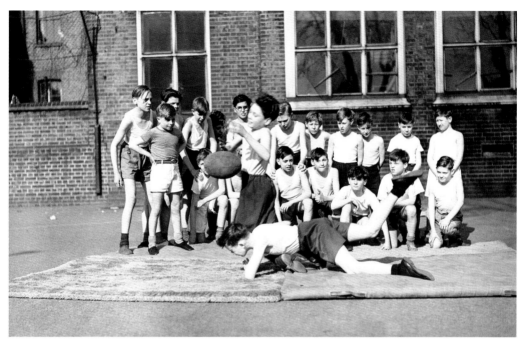

Boys at the Bacon's Free School, Bermondsey, London practice rugby tackling in the school yard. Leather merchant Josiah Bacon, born in the Parish of St Mary Magdalen, Bermondsey, died in 1703, having made provision in his will for the foundation of a school that would catered for poor children whose parents were unable to provide for their education. It taught students free of charge to read English, and do arithmetic such that they were 'fit for a trade or to keep merchants' books'.

17th March, 1955

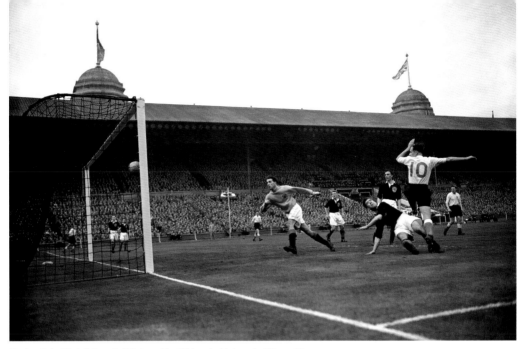

England's inside left Dennis Wilshaw (No 10) heads his team's fifth goal from a corner taken by Stanley Matthews (far L). Scotland goalkeeper Freddie Martin dashes back too late. England went on to win the match 7–2. This black day for Scottish football was a personal tragedy for Martin, whose fumble in the first minute led to the opening goal. Despite Scotland's Lawrie Reilly making the score it 2–1 in 15 minutes, a torrent of English goals trounced the vistors.
2nd April, 1955

Facing page: A section of the huge crowd at Wembley for the England v Scotland international.
2nd April, 1955

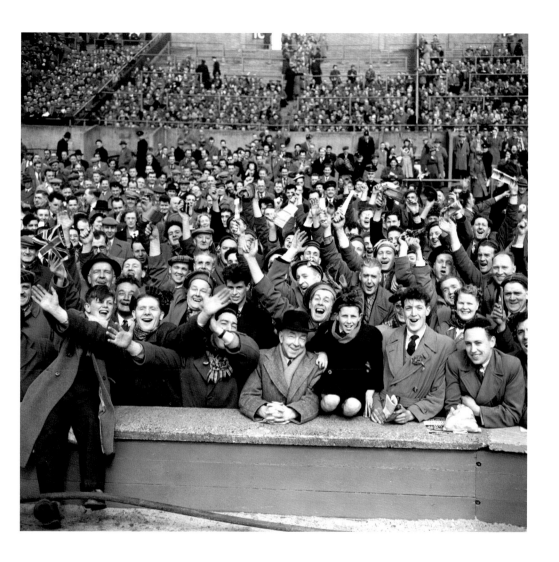

A typical London stall selling books, newspapers and Royal souvenirs.
1st May, 1955

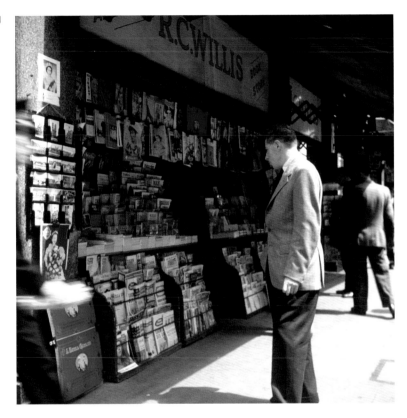

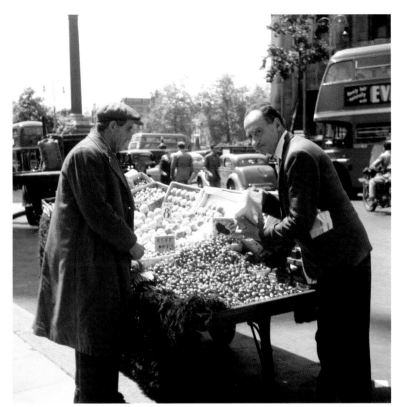

A London 'Barrow Boy' serves a customer from his fruit stall.

1st May, 1955

Labour candidate Michael
Foot (R) campaigning at
Plymouth for the forthcoming
General Election.
17th May, 1955

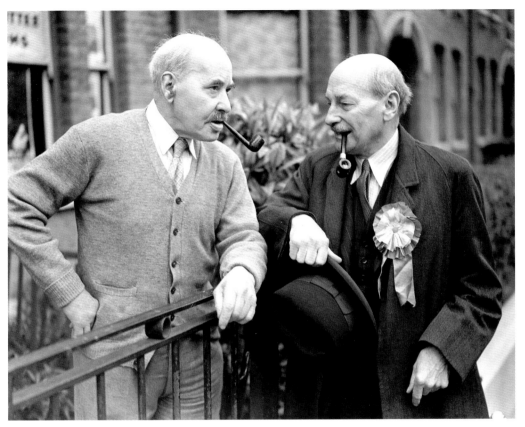

Pipe dreams. Clement Attlee
(R), former Prime Minister,
on the campaign trail for the
General Election.
24th May, 1955

British Lions' Angus Cameron puts on his boots for a training session at Chelmsford Hall School in Eastbourne, Sussex, shortly before the rugby squad's departure for South Africa and the test series that would see his team drawing two games all with the home team, South Africa.

6th June, 1955

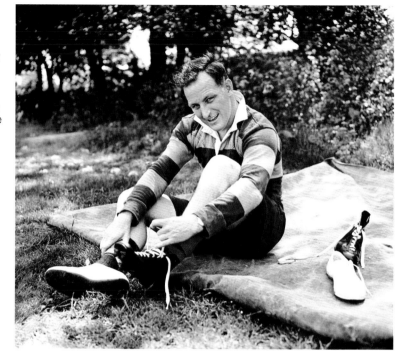

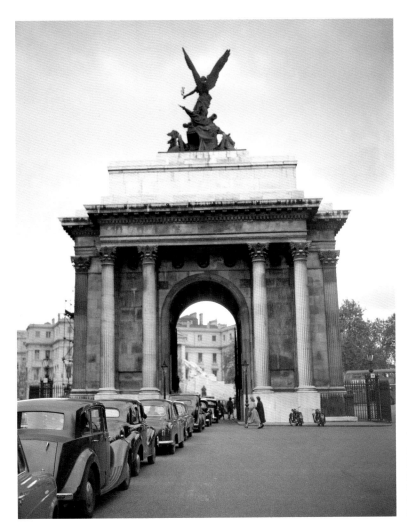

The gate in the Wellington Arch at Hyde Park Corner, London, opened to traffic at the Queen's command to ease traffic congestion caused by a rail strike.
9th June, 1955

John Surtees in his first year with a factory team – Norton – and five years before switching to cars first with Lotus, then Ferrari. Surtees remains the only person to have won World Championships on both two and four wheels.

20th June, 1955

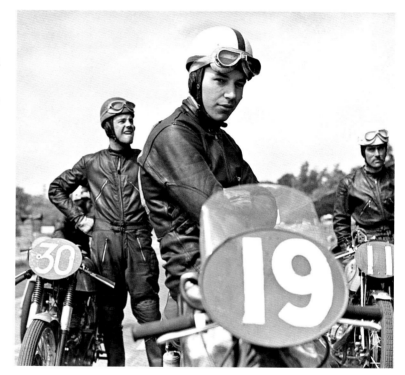

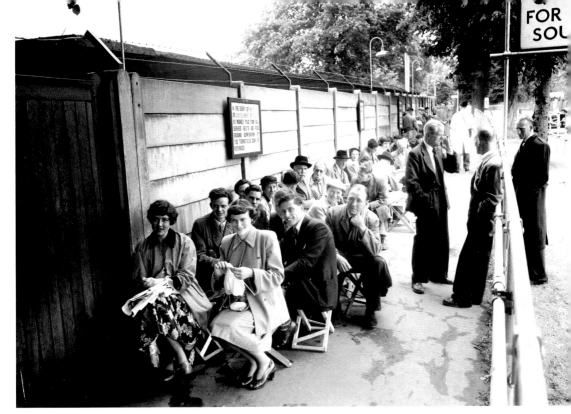

Tennis fans queue patiently outside the gates of the All England Club for the start of the Wimbledon Championships.

20th June, 1955

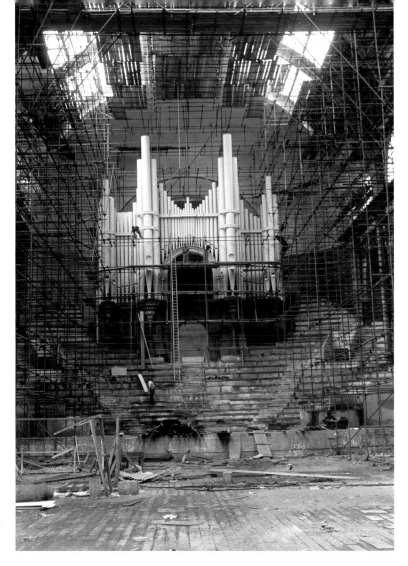

The Great Hall of Alexandra
Palace under repair.
22nd June, 1955

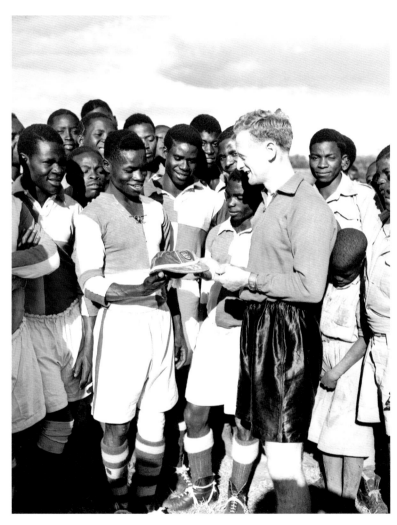

English Footballer of the Year 1954, Tom Finney (R), shows one of his many international caps to the Northern Rhodesia Sportsman of the Year 1953, Inspector Wapamesa of the North Rhodesian Police (L), after giving a coaching exhibition in Lusaka.

11th July, 1955

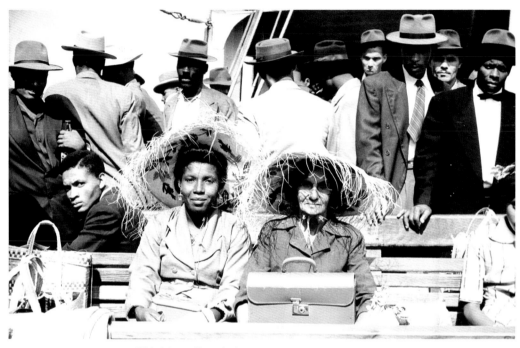

Wide brimmed hats shade from the welcome sunshine of Britain as Jamaicans sail into Plymouth. One thousand and eight people had made the voyage from the West Indies in search of new lives in Britain.

21st August, 1955

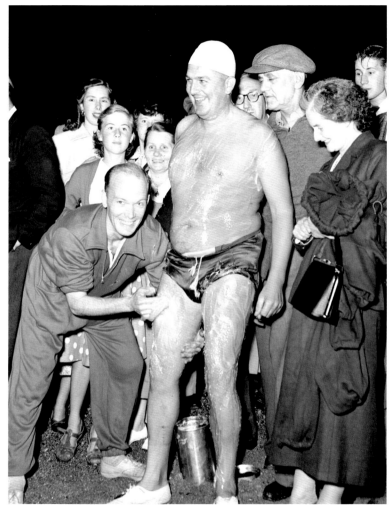

Bill Pickering, 34-year-old baths manager from Bloxwich, Staffordshire is greased down before entering the water at Dover for his attempt to swim the channel. Fifteen stone Pickering completed the challenge in the record time of 14 hours, six minutes.

27th August, 1955

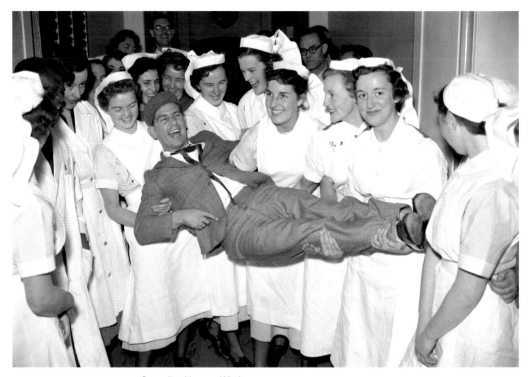

Comedian Norman Wisdom
at Charing Cross Hospital,
London, after presenting two
television sets for the use of
the nurses on behalf of the
Sportsmen's Aid Society.
15th September, 1955

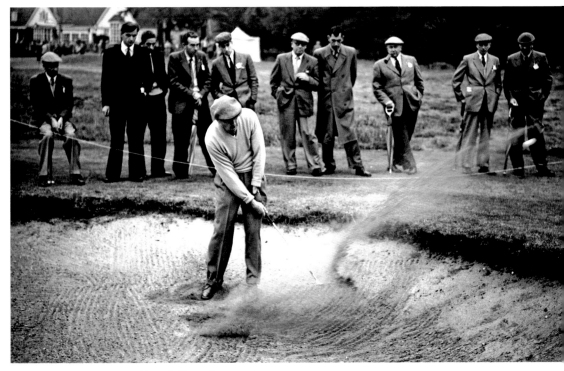

Henry Cotton on the second
day of the Dunlop Master
Golf Tournament at Little
Aston, near Birmingham,
West Midlands.
22nd September, 1955

American singer, songwriter and pianist Johnnie Ray at a reception in a London hotel to celebrate his arrival from New York. Ray flew in to star in the television show *Sunday Night at the London Palladium.* Crash barriers and extra police were needed to control the crowds of screaming girls.

29th September, 1955

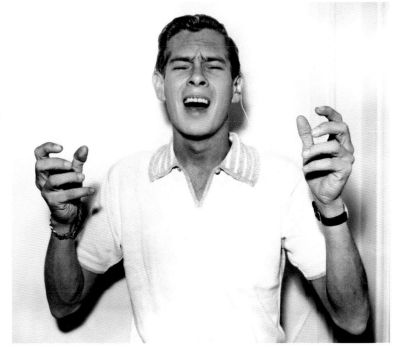

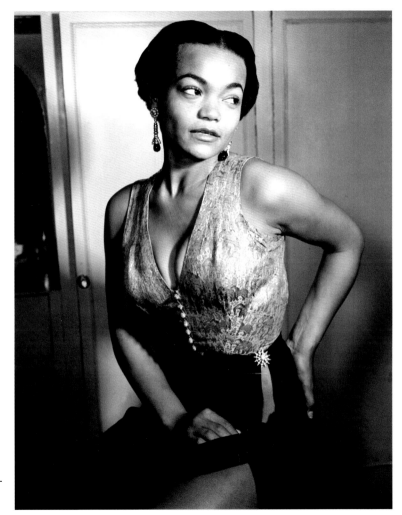

Described as *"one of the most exciting women I've ever seen"* by actor Orson Welles, Eartha Kitt, a singer from South Carolina, USA, is pictured in London with a new fashion hint, the peek-a-boo hip.

30th September, 1955

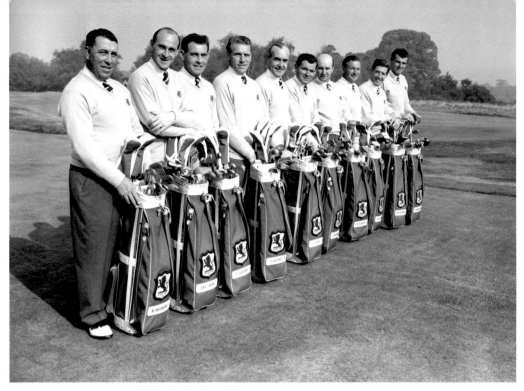

Britain's Ryder Cup golf team at Coombe Hill Golf Club, Surrey. L–R: Harry Bradshaw, Eric Brown, Christy O'Connor, Harry Weetman, John Fallon, Dai Rees, Syd Scott, Arthur Lees, Ken Bousfield and John Jacobs.

12th October, 1955

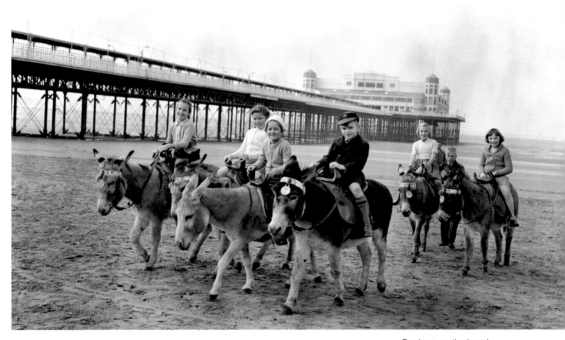

Donkeys on the beach
at Weston-Super-Mare,
Somerset, providing rides for
hundreds of children.
29th October, 1955

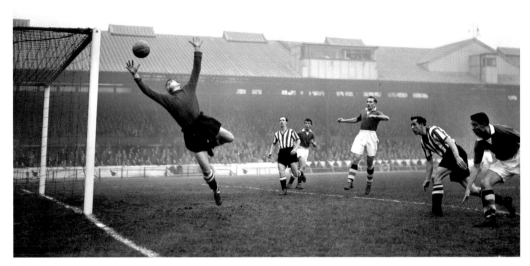

Sheffield United goalkeeper
Alan Hodgkinson dives to
make a save in a Football
League Division One match
against Chelsea.
26th November, 1955

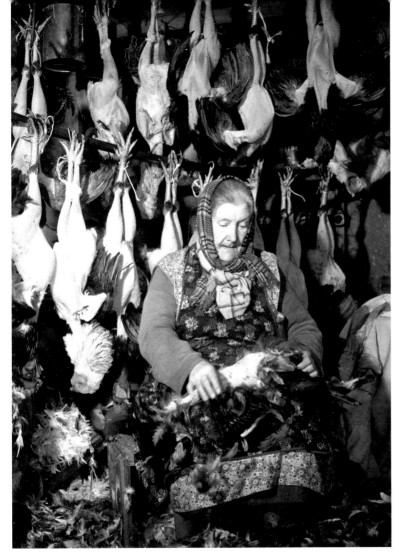

Annie Howells of Brierley Hill, Staffordshire, 77 years of age, first started plucking fowls when she was 11.

23rd December, 1955

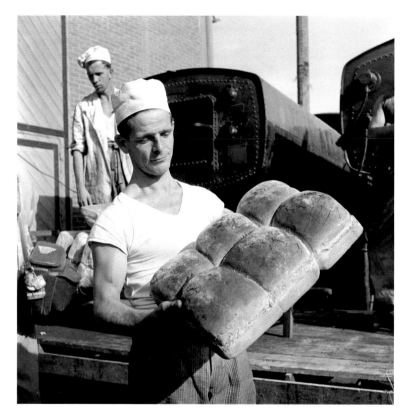

Private Harry Burke bakes bread in the field during the Suez War.
1st January, 1956

Sampling atmospheric pollution in Hendon, north west London. Using a carbon monoxide detector and a vapour detector kit, the men were among 450 volunteers taking part in a full-scale investigation into London smog.

5th January, 1956

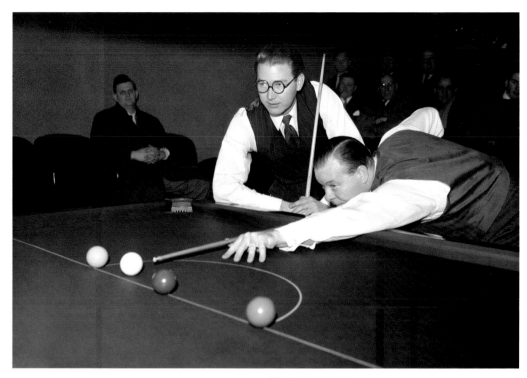

Watched closely by
opponent John Pulman,
Joe Davis breaks off at the
start of the first match in
a snooker tournament at
Burroughes Hall, London.
23rd January, 1956

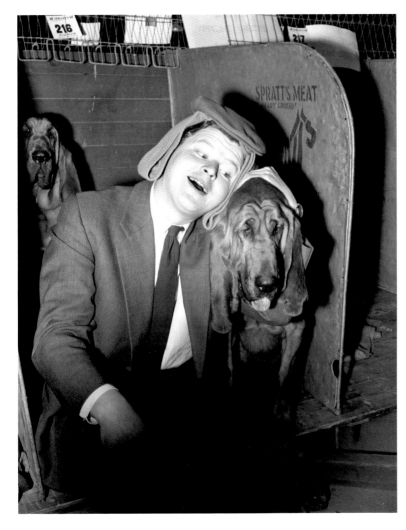

Saucy British comedian Benny Hill with his dog Fabian, who both appeared in Hill's debut film *Who Done It?,* part of which was set in the Cruft's Dog Show at Olympia, London. In the film, the comic's character leaves his job as a road sweeper after winning some money, becoming a private detective who investigates a plot to assassinate British scientists.

10th February, 1956

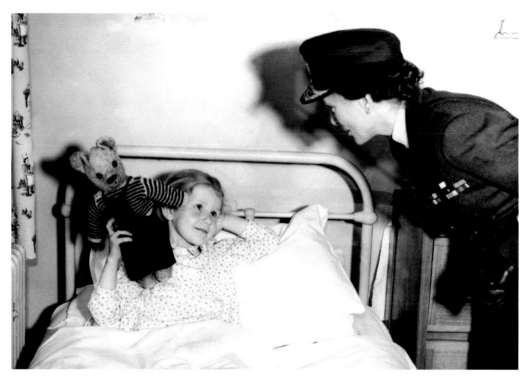

The Duchess of Gloucester
meets five year old Heather
McIntyre and her Teddy
bear at the RAF hospital at
Wroughton, Wiltshire.
13th March, 1956

Cricketer Colin Cowdrey shows children the major trophies of England's three national sports: football's FA Cup (L), cricket's diminutive Ashes (C) and rugby's enormous Challenge Cup.

16th April, 1956

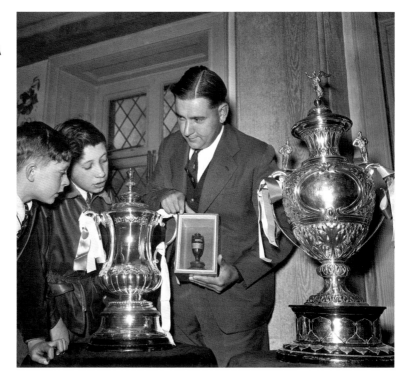

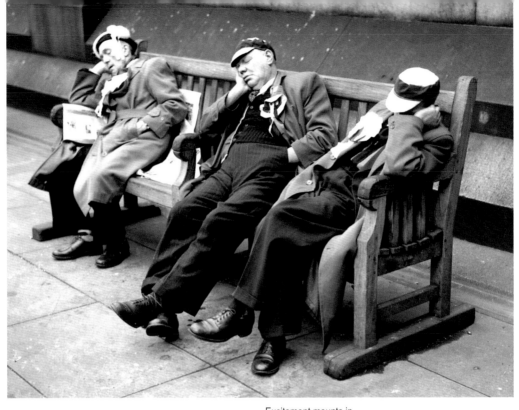

Excitement mounts in Trafalgar Square, London, where these Manchester City fans wait impatiently for their team's match against Birmingham City in the FA Cup Final at Wembley later that day.
5th May, 1956

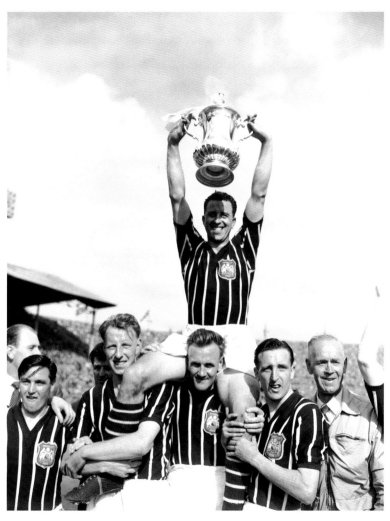

Manchester City captain Roy Paul shows off the FA Cup after his team's 3–1 victory over Birmingham City, supported by teammates (L–R) Bobby Johnstone, Dave Ewing, Don Revie and Ken Barnes.

5th May, 1956

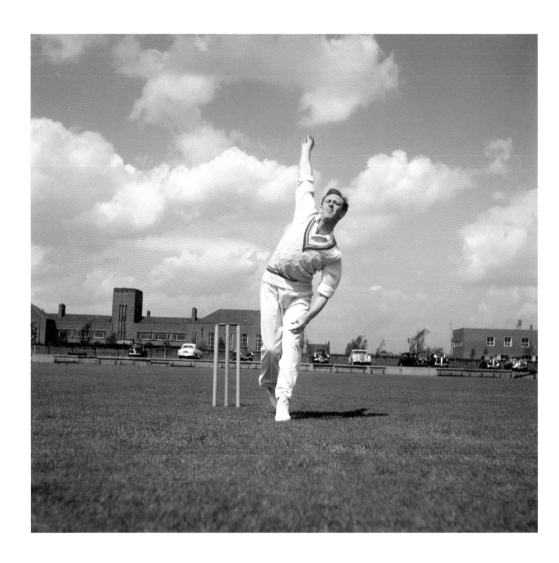

Racing driver Juan Fangio of Argentina takes a well earned drink after winning the British Grand Prix, in a Ferrari, at Silverstone.
14th July, 1956

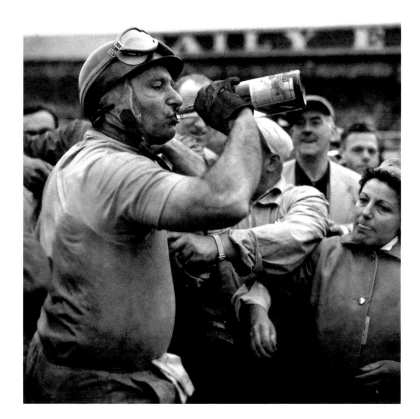

Facing page: Up and over. Brian Statham in action bowling for Lancashire County Cricket Club.
1st July, 1956

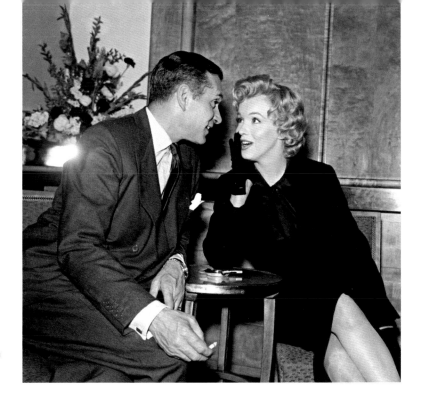

Marilyn Monroe with Sir
Laurence Olivier at the
Savoy Hotel, London. The
two stars acted together in
The Sleeping Prince.
16th July, 1956

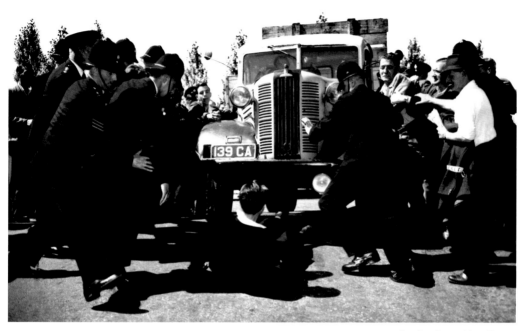

A striker throws himself to
the ground in front of a lorry
at the Austin car works at
Longbridge, Birmingham,
in an attempt to stop the
vehicle entering the factory.
The strike was called by
trade unions following the
dismissal of 6,000 workers.
26th July, 1956

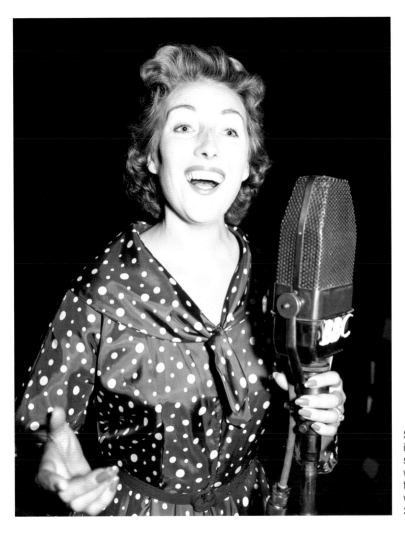

Singer Vera Lynn, rehearsing in London for her radio show *Sincerely Yours*. As a wartime sweetheart of the forces, Vera's signature tune was *Yours*.
30th July, 1956

Private David Shorey (R) of Oxford heads the cookhouse queue for men of the Oxfordshire and Buckinghamshire Light Infantry, recalled from leave as part of the measures taken in the Suez Crisis.
2nd August, 1956

Manchester United Manager
Matt Busby with his 'Babes'
(L–R) Albert Scanlon, Colin
Webster, John Doherty, Tony
Hawesworth, Alec Dawson
and Paddy Kennedy.
3rd August, 1956

Boxer Nicky Gargano in training. The English fighter, who won the gold medal in the welterweight category at the 1954 British Empire and Commonwealth Games took bronze in the same division at the 1956 Summer Olympic Games in Melbourne, Australia.

1st October, 1956

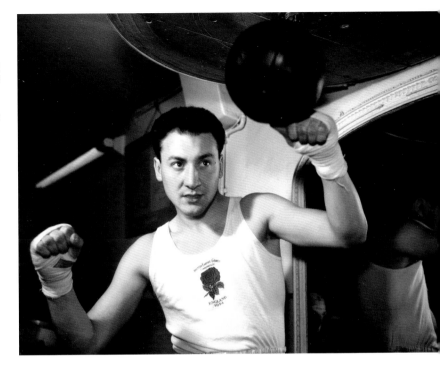

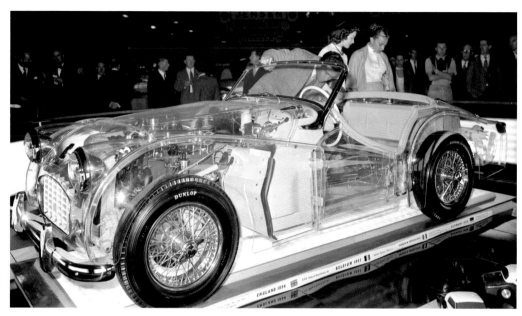

Triumph's new TR3
sports car displayed with
transparent bodywork for the
Motor Show at Earl's Court.
16th October, 1956

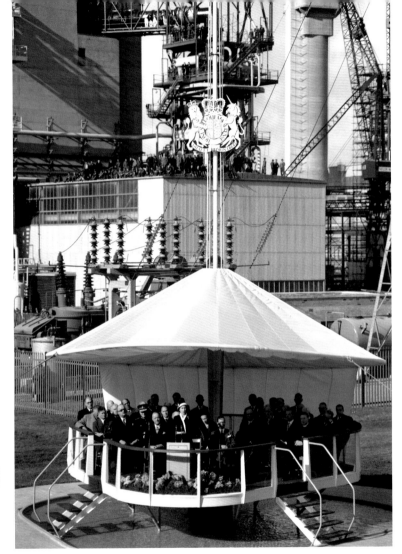

Calder Hall, Cumberland, as the Queen throws the switch that brings it into operation as the world's first full-scale atomic power station, ushering in a new age.
17th October, 1956

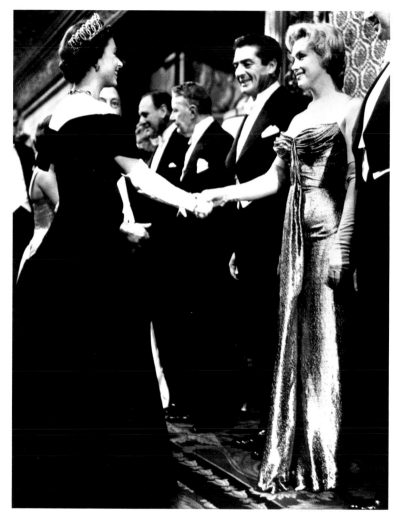

Marilyn Monroe, shaking hands with the Queen at the Empire Theatre, Leicester Square, on the occasion of the Royal Film Performance.
29th October, 1956

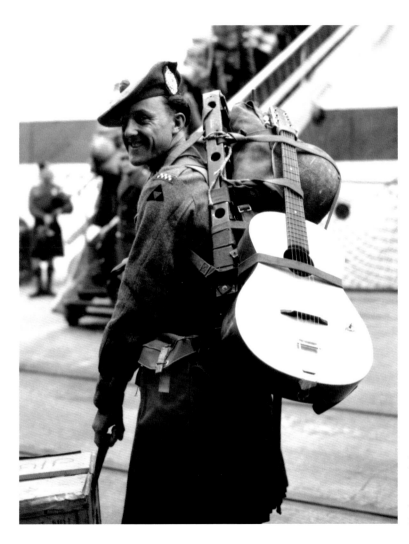

Private T. Elwood, of
Birmingham, takes his
guitar with him as he boards
the troopship *Dilwara* at
Southampton bound for the
Mediterranean area during
the Suez Campaign.
2nd November, 1956

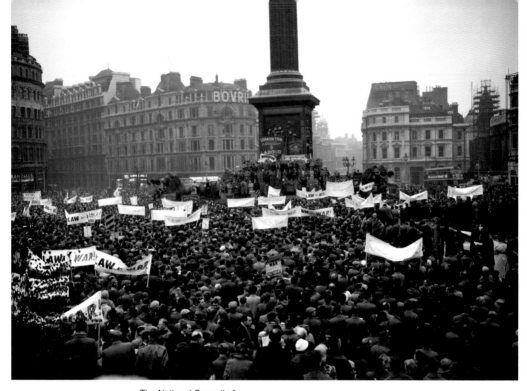

The National Council of
Labour's protest rally against
the government's handling
of the Suez situation, in
Trafalgar Square, London.
4th November, 1956

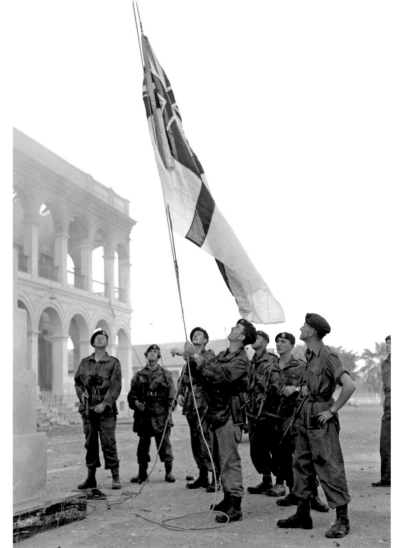

British Royal Marine Commandos raise the White Ensign over Navy House, Port Said, Egypt, just ten minutes after capturing the building in heavy fighting with Egyptian forces during the Suez Crises. The crisis had come about following Egypt's decision to nationalize the Suez Canal on 26th July, 1956. In conjunction with France and Israel, Britain invaded the canal region.
8th November, 1956

Clothes are given to one of the men who fled from Soviet reprisals following the Hungarian revolution, at a London County Council transit hostel in Fulham.

20th November, 1956

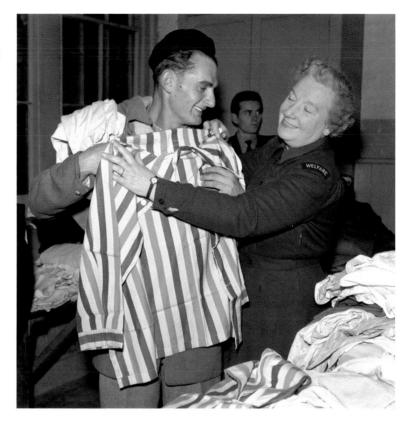

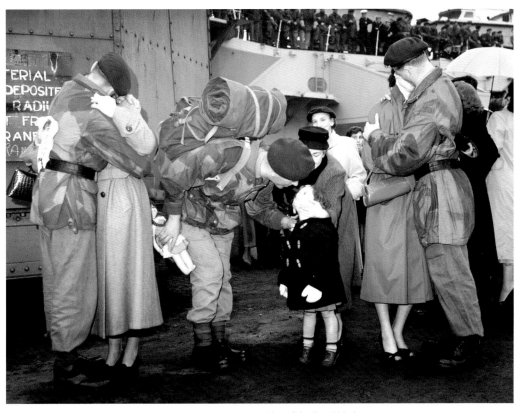

Men of the Royal Marines
Commando returning to
Plymouth from Port Said,
Egypt, after the withdrawal of
British forces from Suez.
8th December, 1956

A motorist hands his coupons to the petrol station attendant as petrol rationing begins in Britain.
17th December, 1956

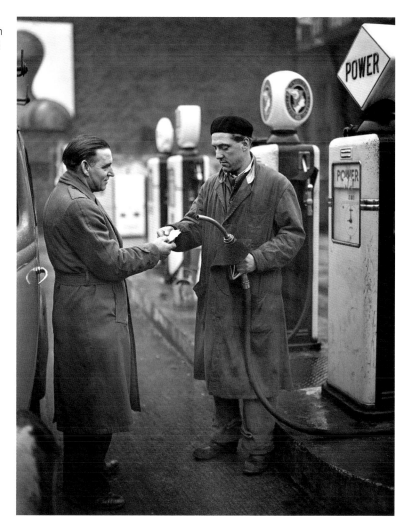

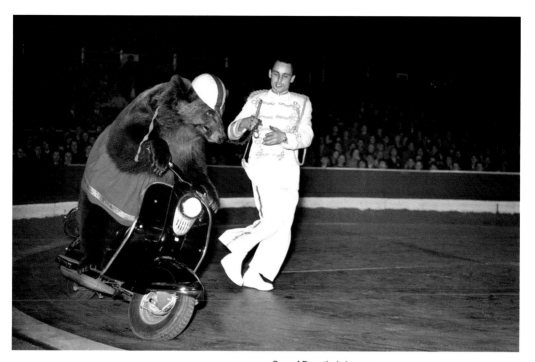

One of Donatha's bears
riding a motor scooter in
Bertram Mills Circus at
Olympia, London.
18th December, 1956

Shirley Bassey (20), then known as 'the Tigress of Tiger Bay', a week before she flew to the United States to fulfil engagements in Las Vegas. She was discovered singing in working men's clubs in her home town of Cardiff, Wales.
10th January, 1957

Harry Secombe with opera singer Adele Leigh (L) and comedienne Joan Sims during a break from work on Harry's first feature film *Davy*, on the Ealing Films set at Elstree in Hertfordshire.
22nd January, 1957

Bournemouth FC manager Freddie Cox (L) in a council of war with his players at the Third Division club's ground in Bournemouth. The men are planning tactics for their fifth round FA Cup tie against Tottenham Hotspur.

13th February, 1957

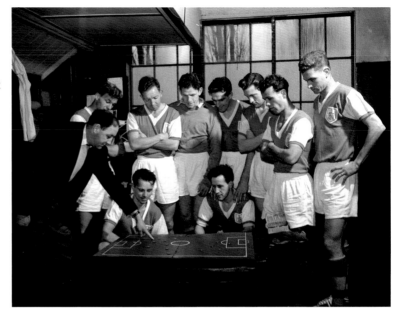

Facing page: Joe Bygraves (L) and Henry Cooper slug it out in the British Empire Heavyweight Championship.

19th February, 1957

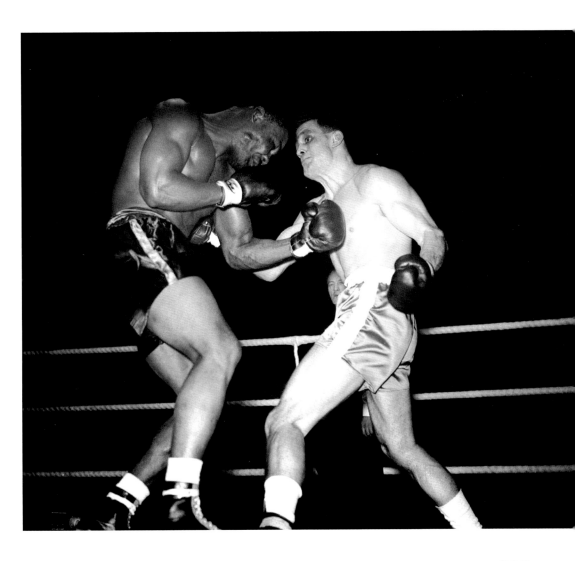

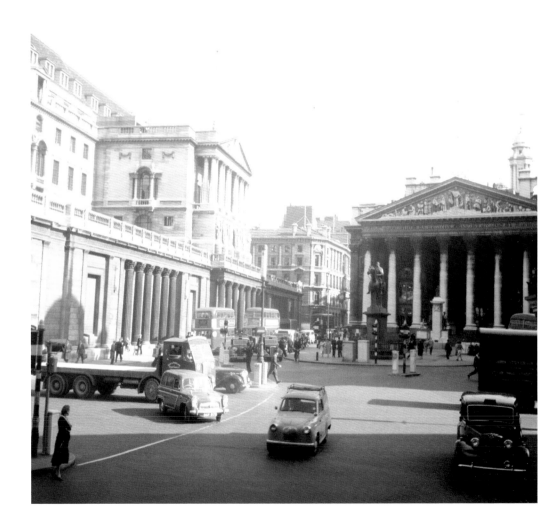

In a ceremony outside the
Savoy Hotel in London,
actress Diana Dors names
an eight-wheeled truck, her
co-star in the film *The Long
Haul*, Diana.
2nd May, 1957

Facing page: Heavy traffic
outside the Bank of England
and the Royal Exchange
in London.
1st April, 1957

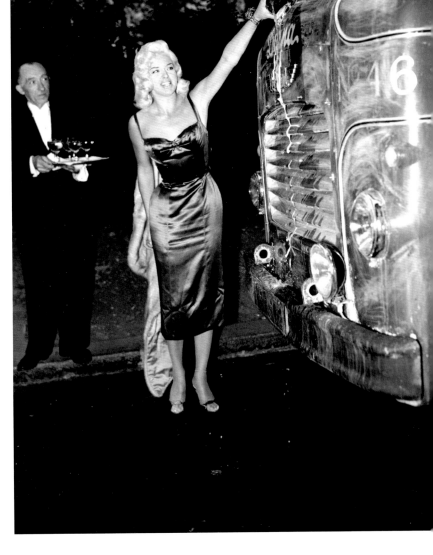

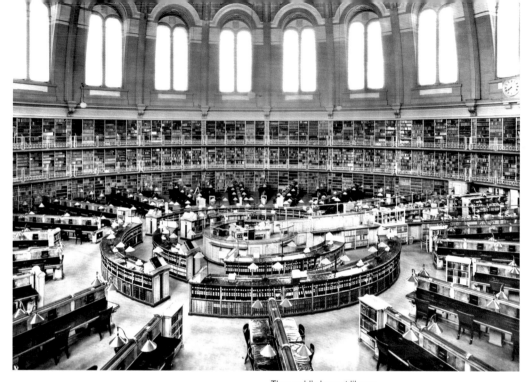

The world's largest library reading room, at the British Museum, in its 100th year. With 80 miles of books and 18 rows of desks, the Reading Room provides accommodation for 390 readers – including such famous names as Marx and Lenin.

2nd May, 1957

Prince Charles shares a word with one of his father's polo ponies at a match in Windsor Great Park.
5th May, 1957

Runner Diane Leather is besieged by autograph hunters after setting a new official world record of four minutes 30 seconds in the 1500m at Hornchurch Stadium in Essex.

16th May, 1957

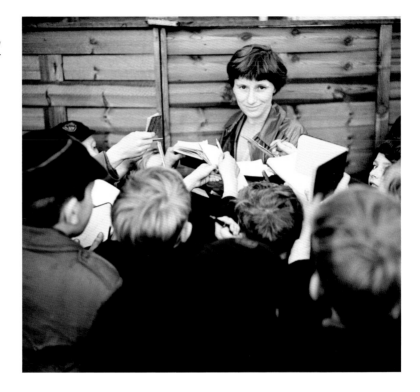

Ernest Marples, the Postmaster-General, presses a button to start up ERNIE (Electronic Random Number Indicating Equipment) for the first Premium Savings Bonds draw, at Lytham St Annes, Lancashire.

1st June, 1957

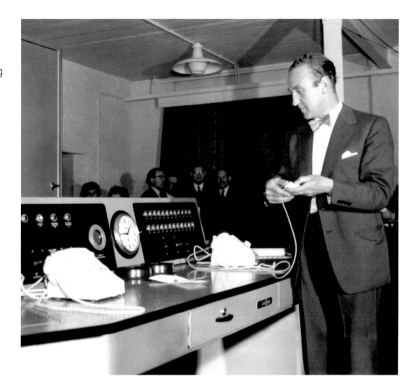

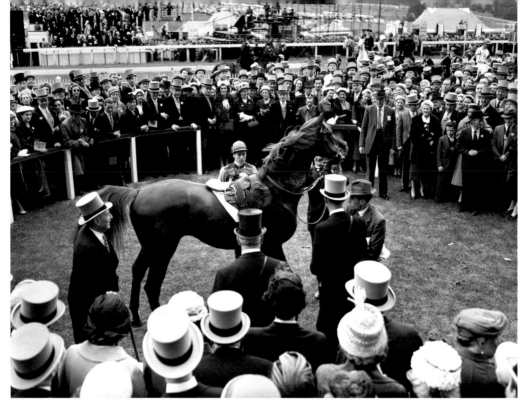

Epsom Derby winner
Crepello and his jockey,
Lester Piggott, receive the
congratulations of Crepello's
owner, Sir Victor Sassoon.
Tendon problems meant
this was the horse's last
race before a career at stud
lasting into the mid-1970s.
5th June, 1957

Facing page: British
Railways' newest express
train *The Caledonian*
leaves Euston Station on its
inaugural run to Glasgow.
On its first (southbound)
run, the express covered
401 miles in 398 minutes,
establishing a new
post-war record.
17th June, 1957

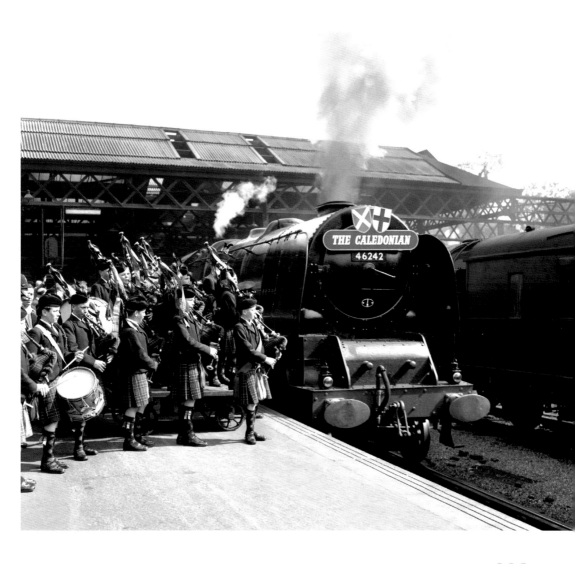

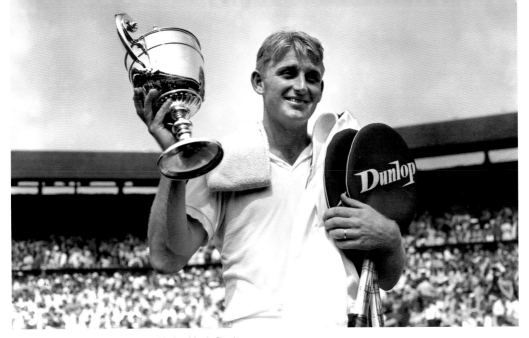

Wimbledon Men's Singles
Champion Australian Lew
Hoad holding the trophy after
beating fellow countryman
Ashley Cooper, 6–2, 6–1,
6–2 in the final.
5th July, 1957

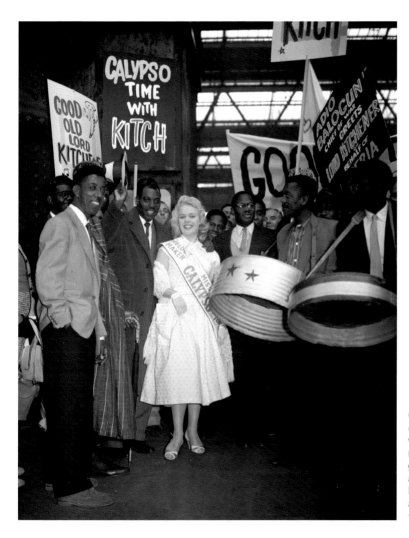

Calypsonian Aldwyn Roberts (second L, raising his hat), who performs under the name 'Lord Kitchener', is greeted on his return from a tour of the USA by Julie Martin (Miss Calypso 1957) and many fans.
18th July, 1957

Sir Laurence Olivier and his wife Vivien Leigh heading a procession to the courtyard of St Martin in the Fields church, Trafalgar Square, London. The public march and meeting had been called to protest against the closing of the St James's Theatre.

20th July, 1957

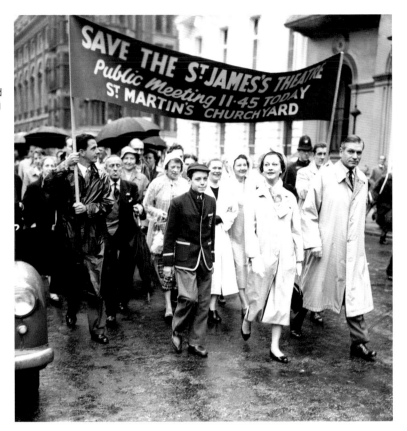

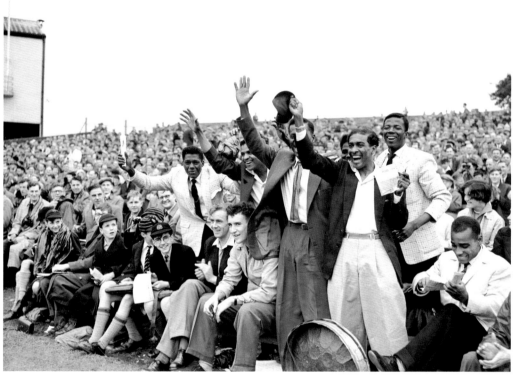

West Indies fans are delighted by the removal of England's Tom Graveney from the crease on the second day of the Fourth Test at Headingley, Leeds.
26th July, 1957

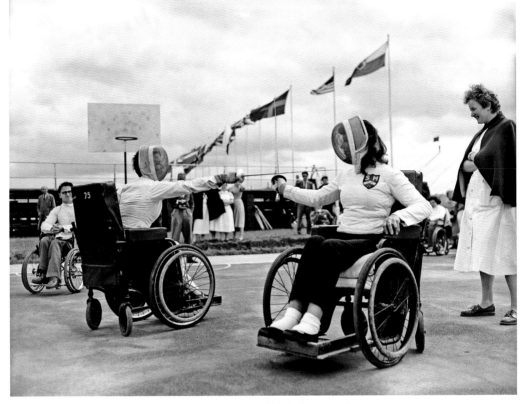

Twenty-five-year-old
Kathleen Yates (L) takes
on 17-year-old Julia
Brockwell in the ladies' foils
championship at the Stoke
Mandeville Paralympics.
26th July, 1957

One of the competitors in the National Town Crier Championship held in Hastings, Mr J.A. Evans of Kirkham, Lancashire, cries for all he's worth.

17th August, 1957

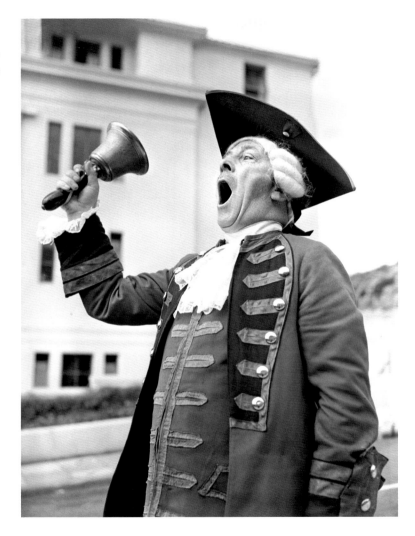

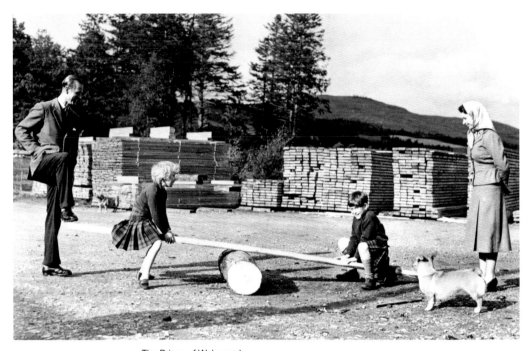

The Prince of Wales and
his sister Princess Anne
are watched closely by their
parents as they play on a
see-saw made from a log
and plank by their father, at
a sawmill on the Balmoral
Castle Estate.
15th September, 1957

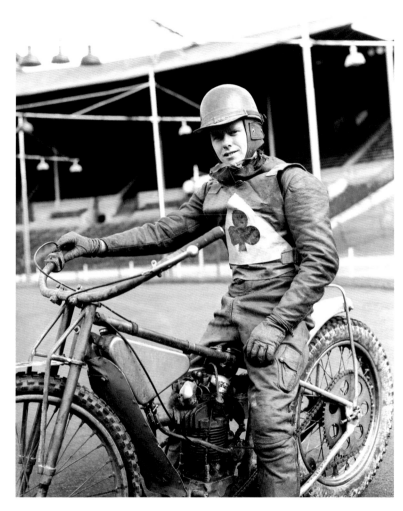

Belle Vue motorcycle rider Peter Craven before the World Championship Speedway Final, in which he took third place.

16th September, 1957

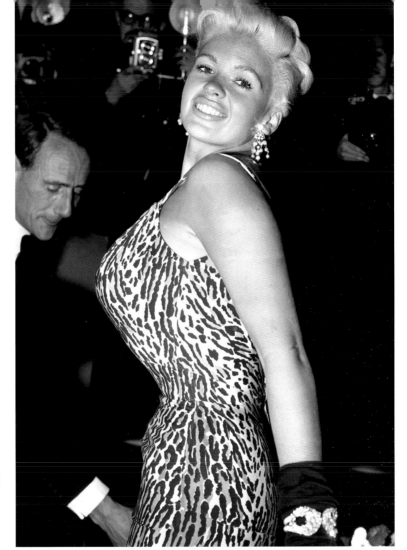

American acrtress Jayne Mansfield, at the Carlton Theatre, Haymarket, London, for the premiere of her film *Oh! for a Man*. Mansfield was one of the blonde bombshells of the 1950s, her platinum blonde hair, hourglass figure and cleavage-revealing dresses making a guaranteed box-office draw. She was the first mainstream starto appear nude in a Hollywood film with sound (*Promises, Promises*). Mansfield was killed in a car crash in 1967, at the age of 34.

26th September, 1957

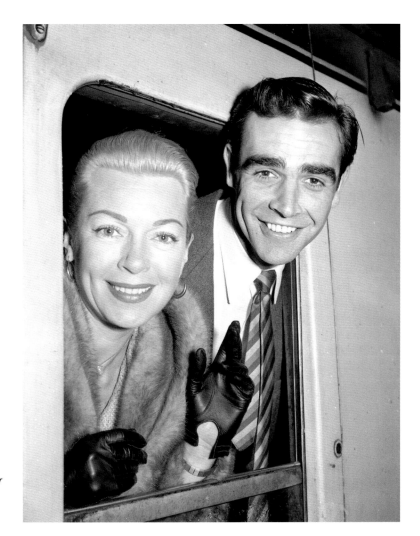

Scottish actor Sean Connery and American actress Lana Turner, who appeared together in the film *Another Time Another Place,* arriving at London King's Cross station.

29th September, 1957

A sunny afternoon and a happy royal family relax in the grounds of Buckingham Palace, London. Princess Anne turns a page of a picture book as her brother, Prince Charles dangles his feet over the water, and the Queen and Duke of Edinburgh look on from the bridge.

9th October, 1957

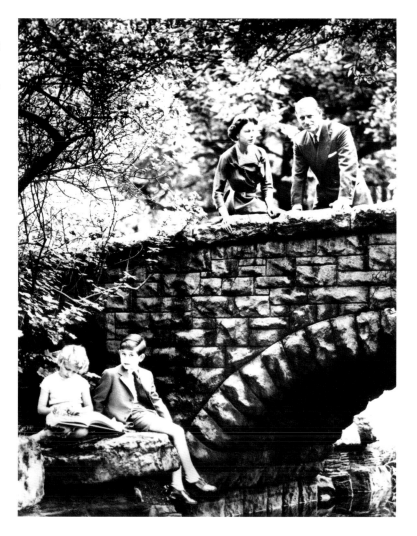

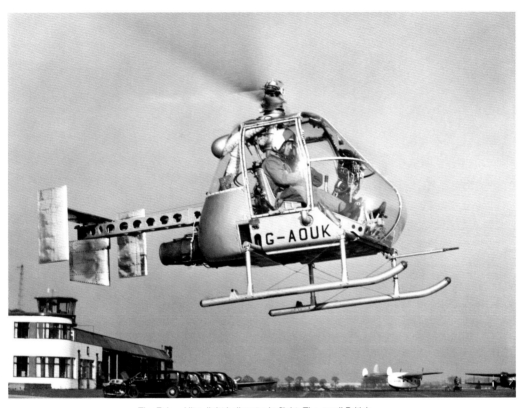

The Fairey Ultra-light helicopter in flight. The small British military aircraft was designed by the Fairey Aviation Company to be low cost and easily transportable for reconnaissance and casualty evacuation. The project, however, was cancelled during defence economies at the end of the decade.

26th October, 1957

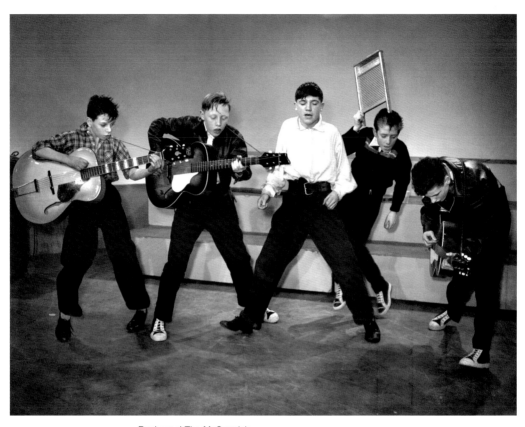

Real gone! The McCormick
Skiffle Group: (L–R) Billy
McCormick, Frank Healy,
Wesley McCausland,
Edward McSherry, and
James McCartney.
19th November, 1957

Ralph Reader, whose *Gang Show* was presented at the Royal Variety Performance, leaves Buckingham Palace after receiving the CBE from the Queen.

19th November, 1957

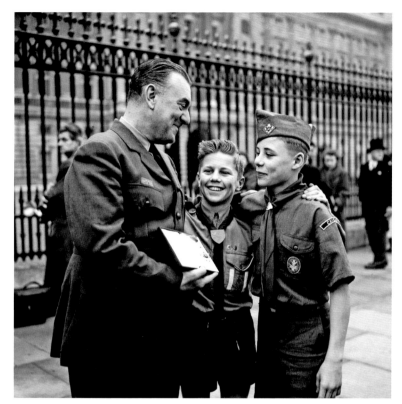

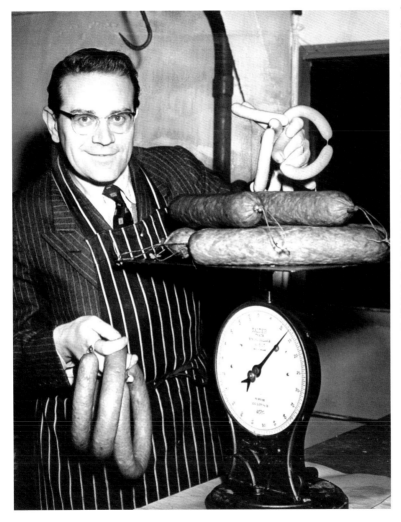

The 1954 Wimbledon men's singles champion, Jaroslav Drobný, weighs a few choice samples of ring, ham and Frankfurter sausages in his continental food factory in Warsop, near Mansfield. The former ice-hockey player left Czechoslovakia in 1949 and travelled as an Egyptian citizen before becoming a citizen of Great Britain in 1959, where he died in 2001. Drobný held the distinction of having competed at Wimbledon under four different national identities. He played at Wimbledon 17 times, always sporting his trademark tinted prescription glasses (a hockey injury had affected his eyesight) and is the only male tennis player to win a Wimbledon singles title while wearing glasses.

21st November, 1957

Donald Campbell, who
holds the world water speed
record with his jet-powered
hydroplane *Bluebird*.
1st January, 1958

Chief National Coach for
Track and Field, Geoff
Dyson (R), instructs a
group of young athletes
on how to start a sprint
at the Amateur Athletics
Association (AAA) Young
Athletes Course at Motspur
Park, south west London.
2nd January, 1958

Wallace Lupino pours a drink in his pub, the *Wooden Fender*, near Colchester, Essex. Lupino, who appeared in 63 films between 1918 and 1940, was part of a British theatrical family whose ancestor was a 17th century Italian émigré. The dynasty was perpetuated by 10 children of dancer George Hook, who assumed the Lupino surname after working with members of Wallace's family, and included the Anglo-American actress, director and pioneer among woman film makers, Ida Lupino, who died in 1995.

13th January, 1958

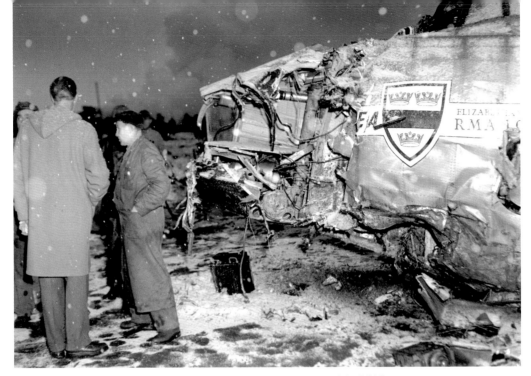

The wreckage of the BOAC Elizabethan charter flight that was carrying the Manchester United football team back from a match in Belgrade, Yugoslavia. After refuelling in Munich, the machine crashed as it tried to take off on the snow-covered runway, killing 23 people, including eight of the team's players.
6th February, 1958

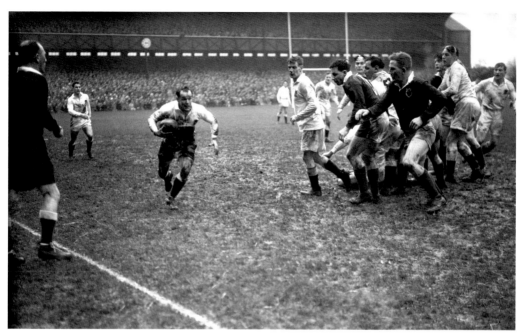

England's Dickie Jeeps (C) makes a break on the narrow side in the Five Nations Championship – England v Ireland. England went on to win the match 6–0.

8th February, 1958

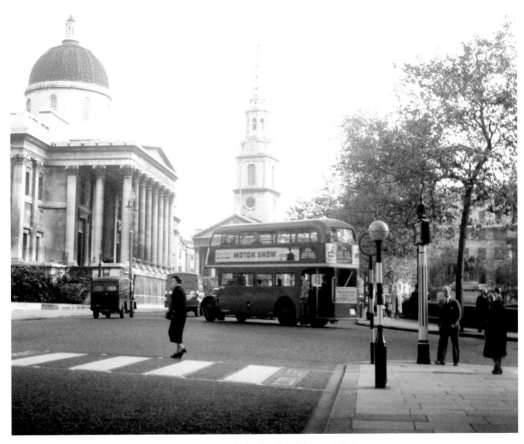

A Routemaster double-decker bus built by Associated Equipment Company (AEC) in 1954 and in production from 1958 until 1968, turns in front of the National Gallery, Trafalgar Square, London. The iconic red bus saw continuous service until 2005, and currently remains on two heritage routes in central London.
1st March, 1958

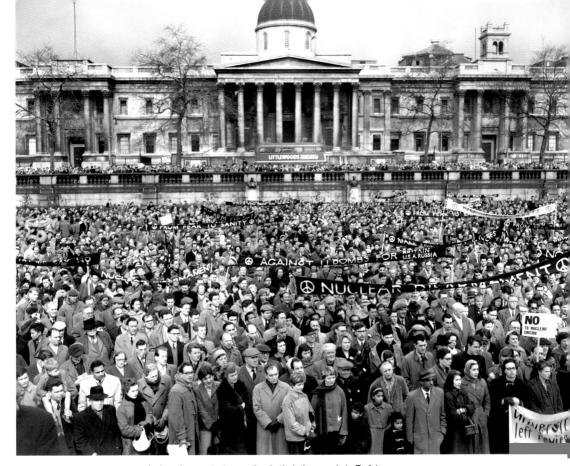

Anti-nuclear protestors gather in their thousands in Trafalgar Square for the start of a 50-mile protest march from London to the Atomic Weapons Research Establishment at Aldermaston in Berkshire. The Aldermaston marches were organised by the British anti-war Campaign for Nuclear Disarmament (CND) in the 1950s and 1960s on the Easter weekend.
4th April, 1958

Motorcycle Grand Prix
Champion Mike 'The Bike'
Hailwood MBE, laden with
his collection of trophies.
12th April, 1958

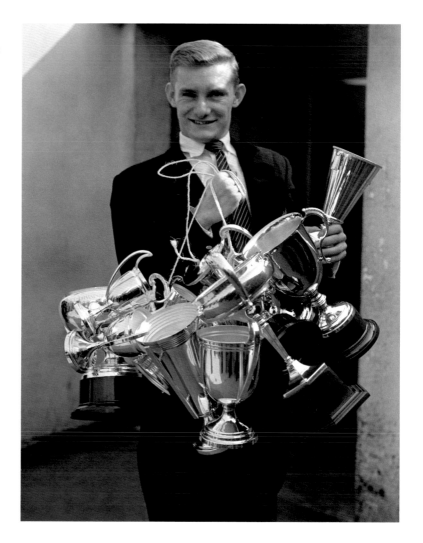

A fresh-faced Brian Clough made his debut in the 1956–57 season with Middlesbrough Football Club, and helped the club to 14th place, before going on to carve a name for himself in the sport and in history. Here, Clough poses for the press before a Football League Division Two match against Fulham.

21st April, 1958

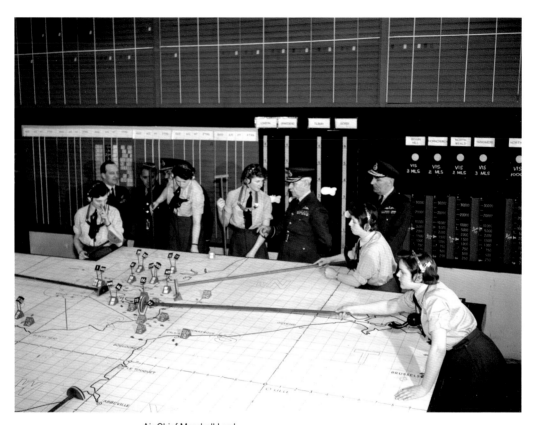

Air Chief Marshall Lord Dowding (C) visits the reconstructed underground operations room and nerve centre of No 11 Group Fighter Command during the Battle of Britain in 1940, to unveil a plaque.

22nd April, 1958

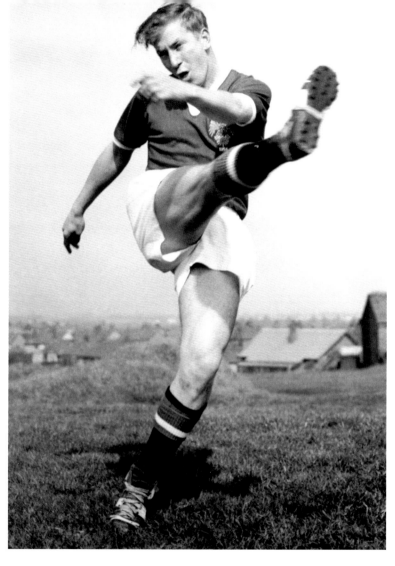

Bobby Charlton, who is
to play centre-forward for
Manchester United against
Bolton Wanderers in the FA
Cup Final at Wembley.
1st May, 1958

Bob Roden from Manchester jumps for joy at the prospect of seeing his beloved Manchester United at Wembley Stadium against Bolton Wanderers in the FA Cup Final. In front of a crowd of almost 100,000, Bolton won 2–0, with a double by Nat Lofthouse in the 3rd and 55th minutes. United, who had lost the previous final to Aston Villa, had been decimated three months earlier in the Munich air disaster, and fielded only four crash survivors, along with several newcomers.

3rd May, 1958

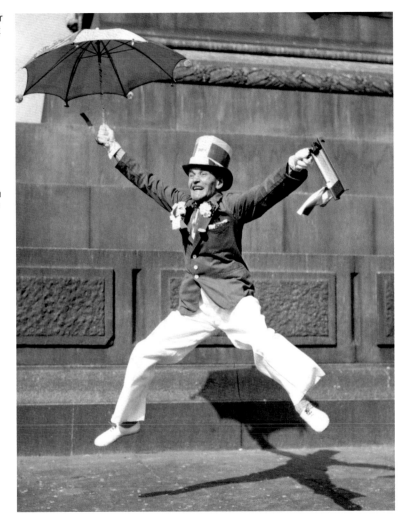

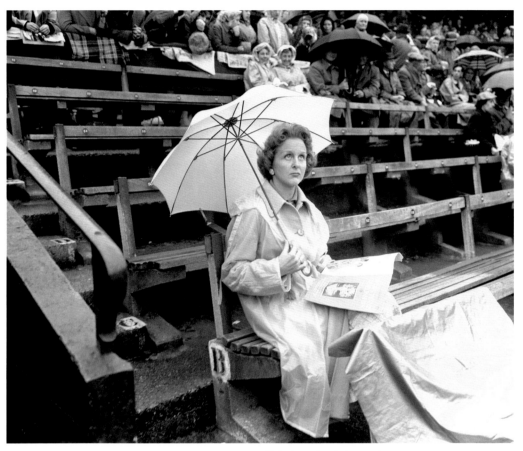

Rain stops play. A downcast
Wimbledon spectator gazes
up at the rain clouds from
beneath her umbrella.
28th June, 1958

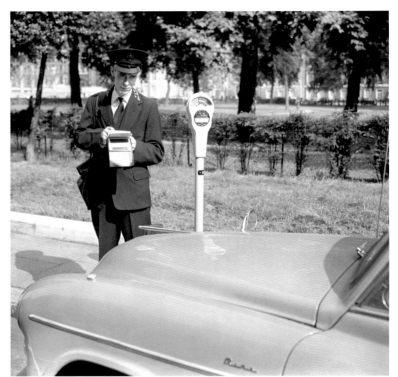

One of the first parking meter defaulters is booked in Grosvenor Square by traffic warden Mr W. Matthews, when Britain's first parking meter experiment came into operation in Mayfair, London.
10th July, 1958

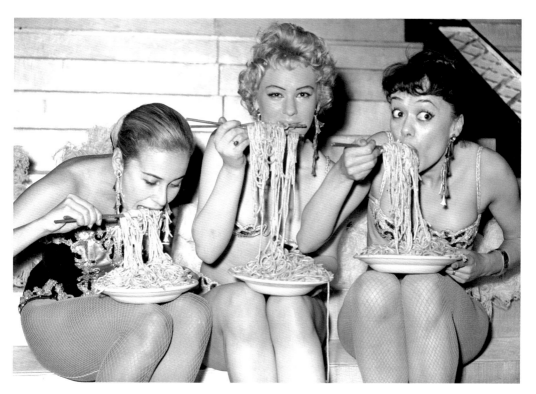

What a mouthful! L–R:
Showgirls Kathryn Keeton,
Mariella Capes and Hazel
Gardner, at the Soho Fair
spaghetti eating contest.
10th July, 1958

Matt Busby, manager of
Manchester United FC, with
his wife and son Sandy after
he was awarded the CBE by
the Queen.

22nd July, 1958

Motor power. Australia's British Empire and Commonwealth Games cycling team use a motorbike to travel between the camp and the bicycle track, Cardiff, Wales.
23rd July, 1958

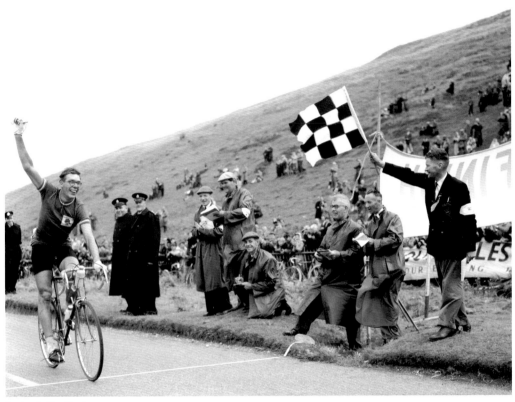

England's Ray Booty
celebrates victory as he
takes the chequered flag
in the 120-mile road race
at The British Empire and
Commonwealth Games,
Cardiff, Wales.
26th July, 1958

Facing page: John Surtees racing an MV Agusta 350cc. He
won the Junior and Senior Isle of Man TT races in this year,
as well as winning every Grand Prix he entered to capture
both the 350 and 500cc World Championships.
31st July, 1958

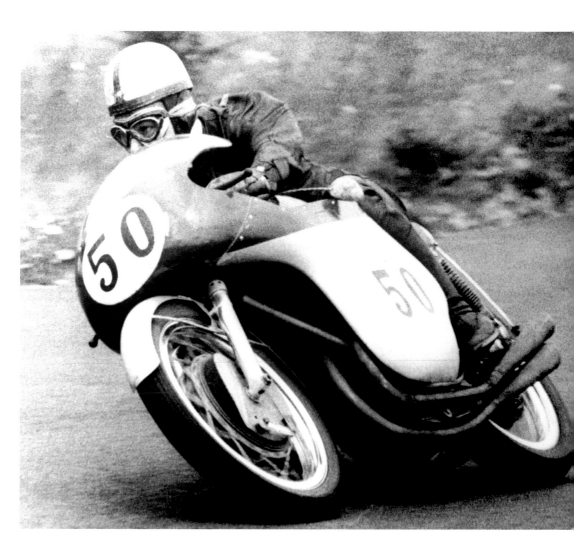

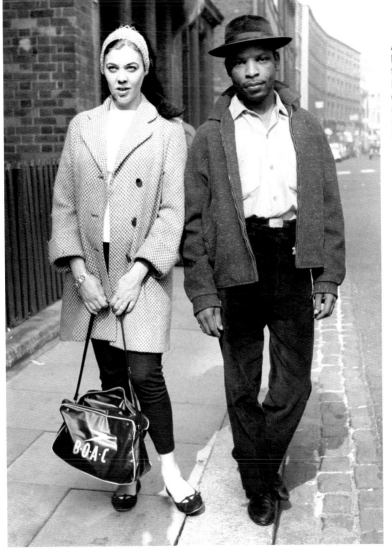

A West Indian man and his white girlfriend walk through the streets of Notting Hill Gate, London, despite the threat from right-wing thugs following race riots in the area.
2nd September, 1958

Facing page: Shopkeepers bail water out of their flooded premises in Chelmsford, Essex. The town was one of the worst affected by a great storm the previous night.
6th September, 1958

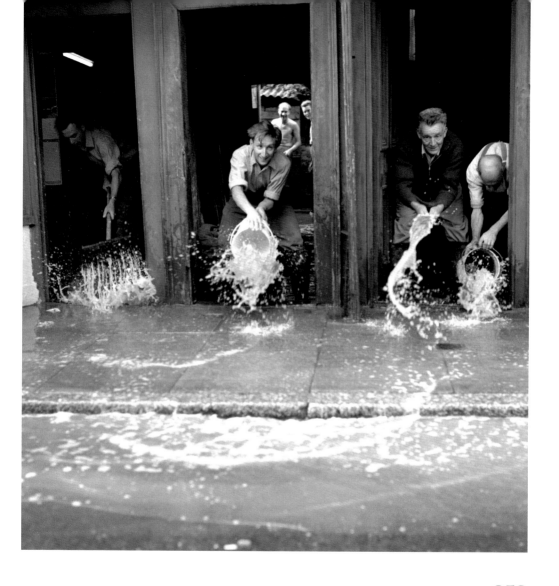

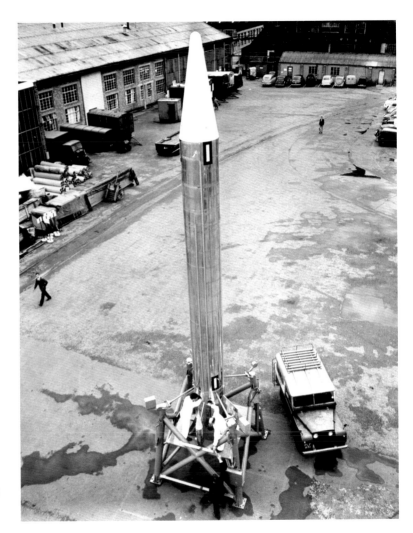

The 'Black Knight' guided
missile, built and tested on
the Isle of Wight.
7th September, 1958

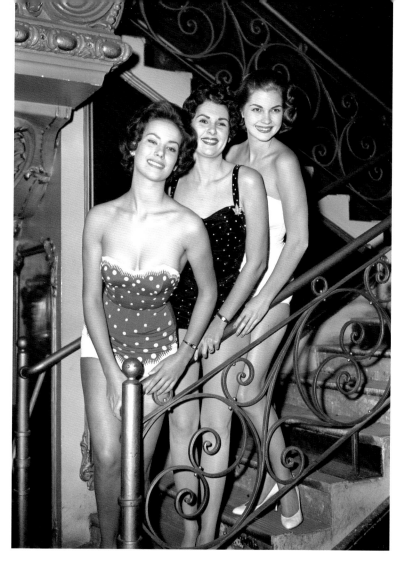

Three competitors in the Miss World beauty contest at the Lyceum Theatre, London, where the final of the competition was to take place. L–R: Claudine Oger (Miss France), Marilyn Anne Keddie (Miss Canada) and Penelope Anne Coelen (Miss South Africa). Miss Coelen was crowned, with Miss Oger first runner up. The United Kingdom's Eileen Sheridan took fifth place.
6th October, 1958

Manchester United and England footballer Bobby Charlton, aided by his mother, Betty, lights the candles on his 21st birthday cake at his home at Ashington.

13th October, 1958

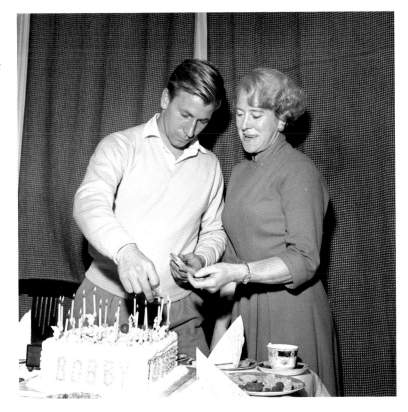

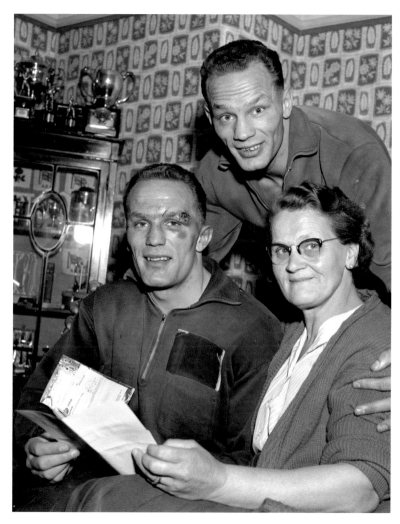

A bruised, but smiling, Henry Cooper (L), who upset the world boxing rankings with his win over highly rated American Zora Folley at the Empire Pool, Wembley, reads messages of congratulation at his Bellingham, Kent home the next day. With him are his mother and identical twin brother, George (who also boxed, as Jim Cooper), Henry was eager for a match with American world champion Floyd Patterson.

15th October, 1958

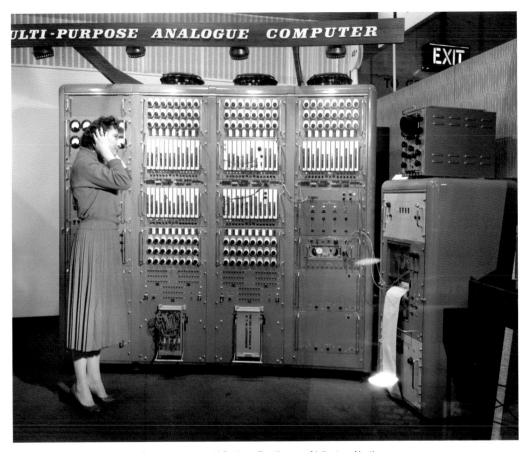

Seventeen-year-old Barbara Rawlinson, of Islington, North London, is horrified by the many dials and controls of the Fairey Multi-Purpose Electronic Analogue Computer at the Electronic Computer Exhibition, Olympia, London.
28th November, 1958

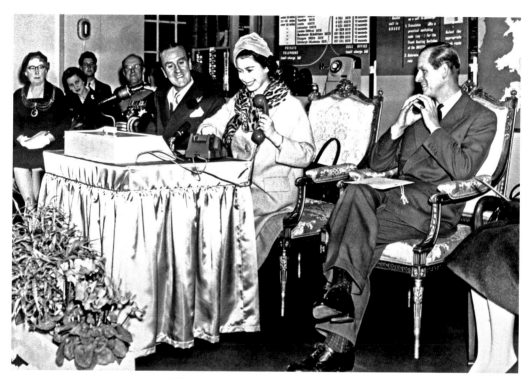

Queen Elizabeth makes
the UK's first subscriber
trunk dialled telephone call
from the Bristol Telephone
Exchange.
5th December, 1958

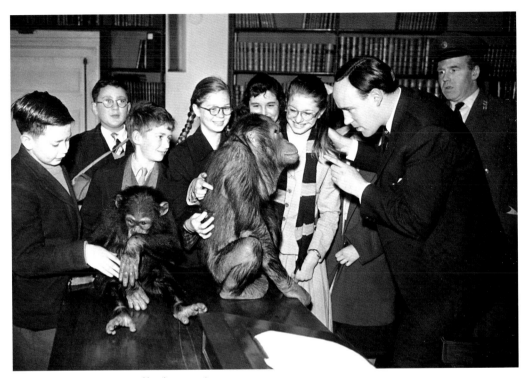

Alex the orangutan pays close attention as zoologist Dr Desmond Morris gives a lecture to school children at London Zoo.

29th December, 1958

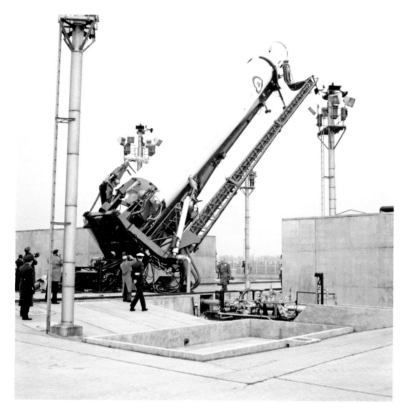

A PGM-17 'Thor' intermediate range ballistic missile being raised to launching position at RAF Feltwell.

January, 1959

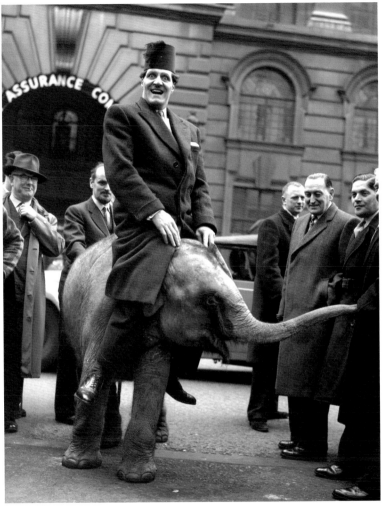

Noted for his red fez and his lumbering at six-foot-four inch frame, comedian and magician Tommy Cooper rides a baby elephant.
23rd February, 1959

Facing page: Mr Ted Smith, stockman on the Earl of Bathurst's estate, Cirencester Park, Gloucestershire, with Jim and Joey, the last two working oxen in Britain.
1st March, 1959

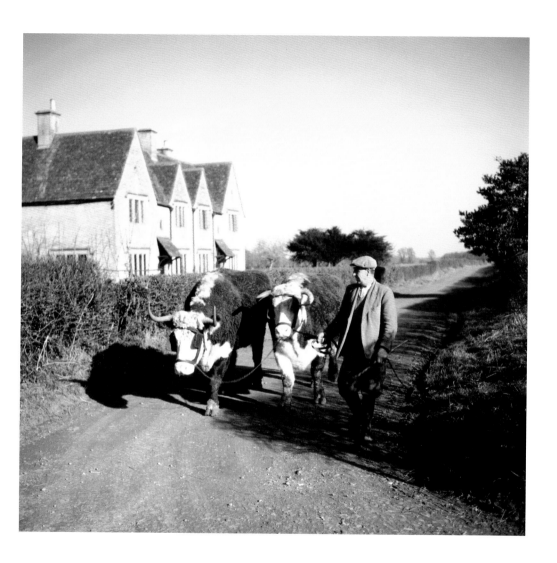

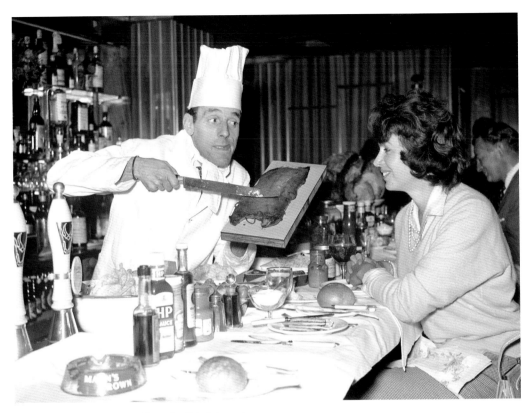

Comedian Eric Sykes acts
as chef to Italian-born
British film actress Marla
Landi at the Springbok Club,
Shepherds Bush, London.
22nd March, 1959

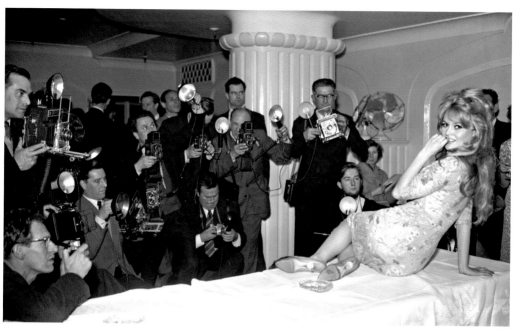

French fashion model, actress and singer Brigitte Bardot at a London Hotel during a photocall after arriving from Paris to start location shooting for her film *Babette Goes to War*. Two months later Bardot, who had previously been married to film director Roger Vadim, married actor Jacques Charrier, who she starred with in the film.

9th April, 1959

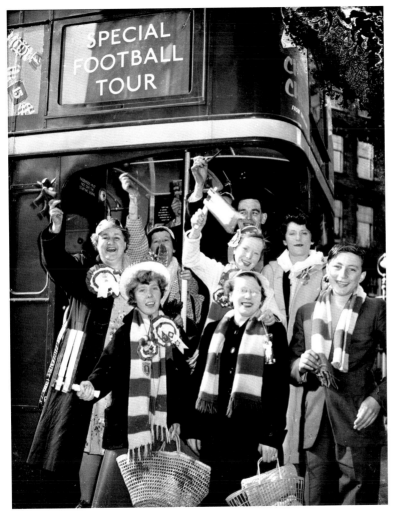

Nottingham Forest fans
board a London sightseeing
bus to take in the sights
before the FA Cup Final with
Luton Town at Wembley.
2nd May, 1959

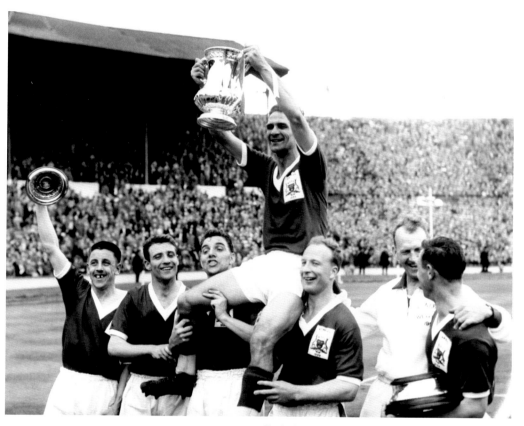

Nottingham Forest captain
Jack Burkitt lifts the FA
Cup after his team's 2–1
victory over Luton Town at
Wembley.
2nd May, 1959

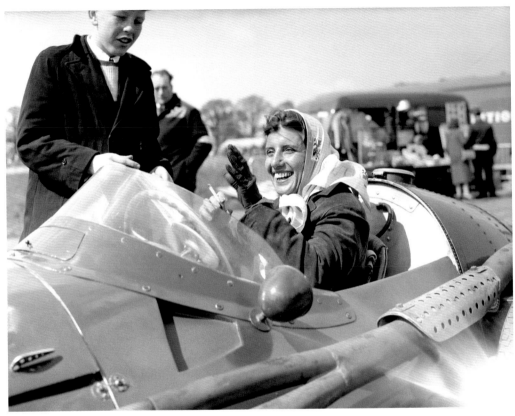

Italian Maria Teresa de Filippis has a quick smoke in her Maserati at Silverstone. She was the first of five female Formula One racing drivers in the sport's history and participated in five World Championship Grands Prix, debuting on 18th May, 1958, although she scored no championship points.

2nd May, 1959

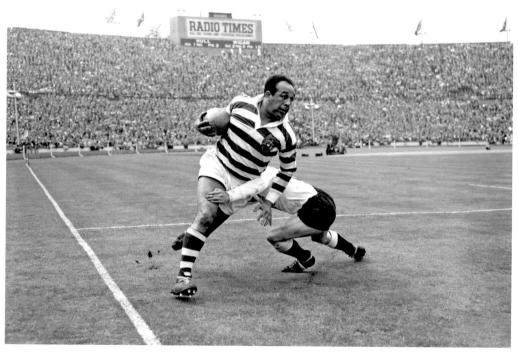

Legendary Wales and Great
Britain Rugby League star
Billy Boston skilfully avoids
a tackle.
9th May, 1959

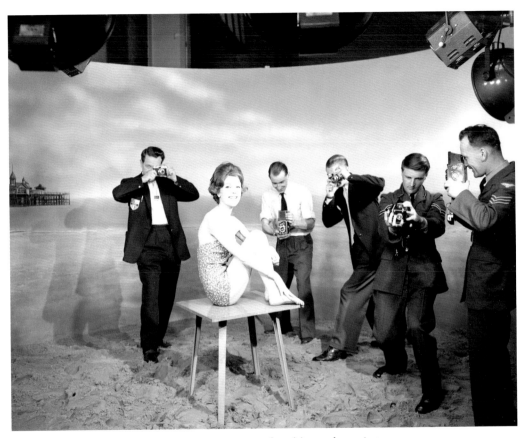

A model poses for amateur photographers at the International Photo Fair at Olympia, London.
11th May, 1959

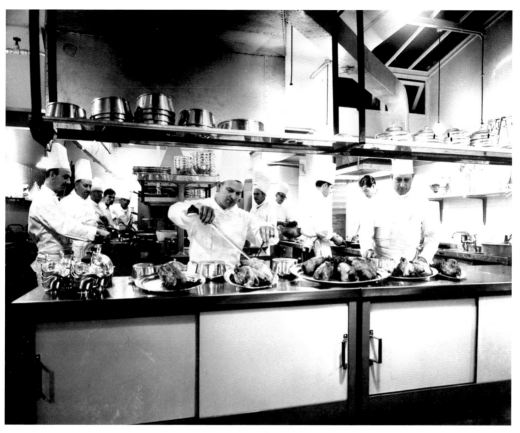

Chefs preparing poultry for
serving at the Talk of the
Town Restaurant – formerly
the London Hippodrome
Theatre.
2nd June, 1959

American entertainer Liberace arriving at the Law Courts for his libel action against the *Daily Mirror* newspaper. A 1956 article in the newspaper by veteran columnist Cassandra (William Connor) implied that Liberace was homosexual. He sued for libel, testifying in court that he was not homosexual and had never taken part in homosexual acts. He won the suit, partly on the basis of the term 'fruit-flavoured', used in the article, which was held to impute homosexuality. The £8,000 damages he received from the *Daily Mirror* led Liberace to state to reporters: "*I cried all the way to the bank!*"

10th June, 1959

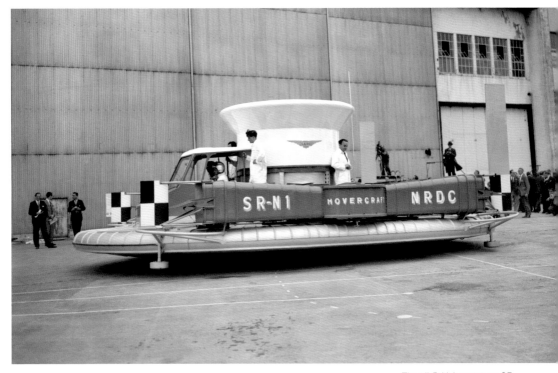

The all-British prototype SR N1 hovercraft, designed by Christopher Cockerell and made by Saunders Roe, during a demonstration at Cowes, on the Isle of Wight.
11th June, 1959

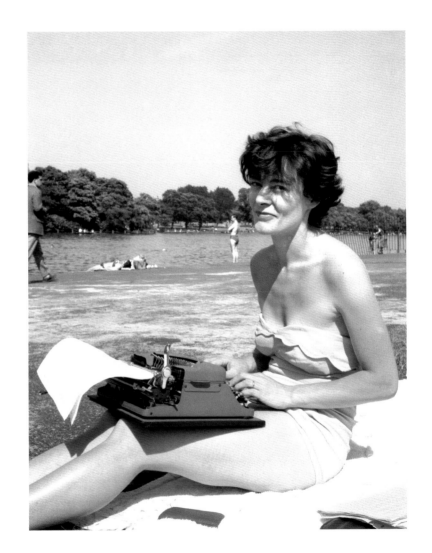

Miss Lynn McNamee
typing in the sunshine
at the Serpentine during
a heatwave.
18th June, 1959

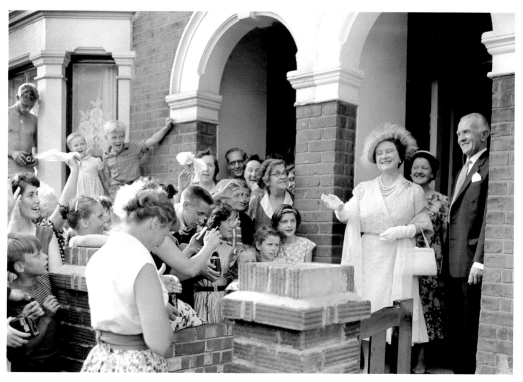

The Queen Mother on the
steps of 174 Villiers Road,
Willesden, where she visited
its garden and many others
in the area. The garden was
chosen as one of the best
in the district by the London
Garden Society.
8th July, 1959

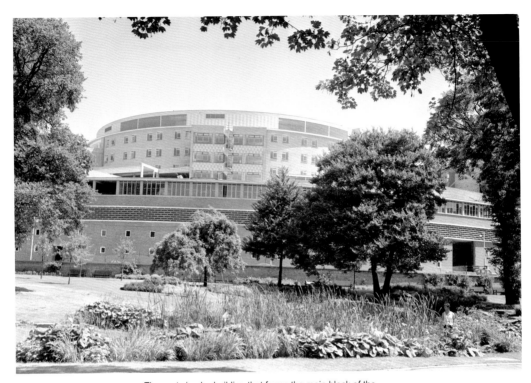

The vast circular building that forms the main block of the British Broadcasting Corporation's Television Centre in Wood Lane, London. When finished the building, shaped like a giant question mark, and designed by Mr Graham Dawbarn, FRIBA, was to be Europe's biggest TV centre.

14th July, 1959

A breakdown gang with their huge crane work to put a steam locomotive back on the rails after a crash at St Pancras Station, London.
29th July, 1959

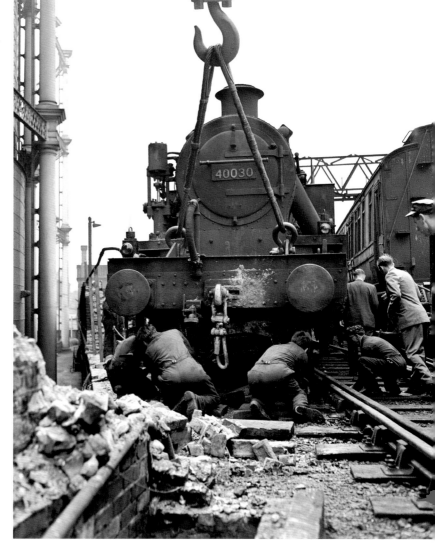

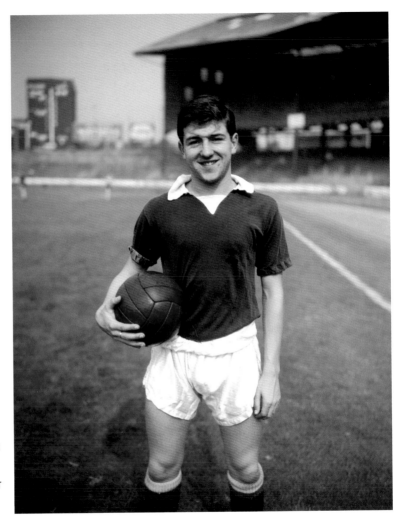

Terry Venables, of Chelsea football club. He had left school in the summer of 1957 and signed for the club as an apprentice, becoming professional for them in 1960, becoming a key player and later captain.
1st August, 1959

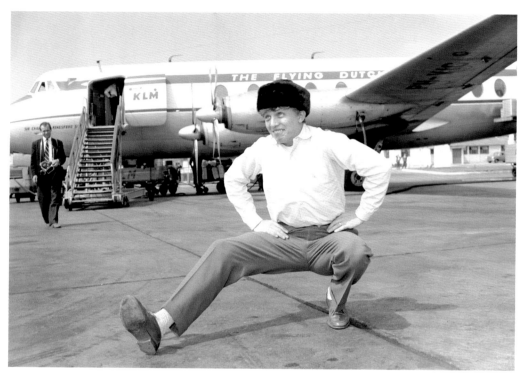

Tommy Steele performs a
traditional Russian dance
on the tarmac at Heathrow
Airport, on his return from
Moscow. The entertainer is
widely regarded as Britain's
first teen idol and rock 'n'
roll star.
8th August, 1959

A scene at Speaker's Corner, Hyde Park, London, where anyone is permitted to talk on any subject, so long as the police consider their speeches to be lawful. Police are generally tolerant and intervene only when a complaint is received, or if they hear profanity. Famous speakers who have mounted the soapbox to state their case have included Karl Marx, Vladimir Lenin and George Orwell.

18th August, 1959

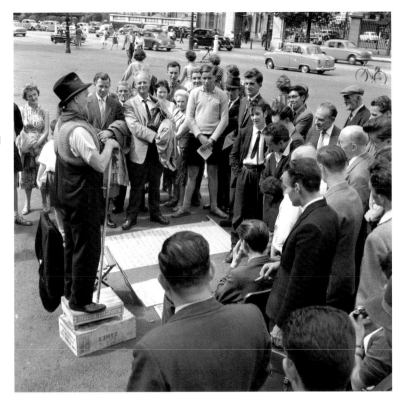

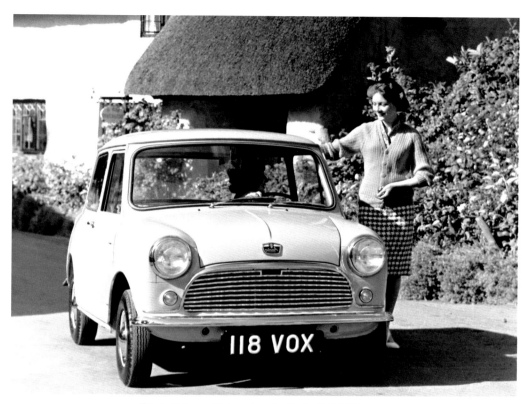

The revolutionary Mini was launched by the British Motor
Corporation in 1959. It was a unique concept with a
transverse mounted engine, front wheel drive and four seats
in a compact package. It went on to achieve great popularity
and competition success.
1st September, 1959

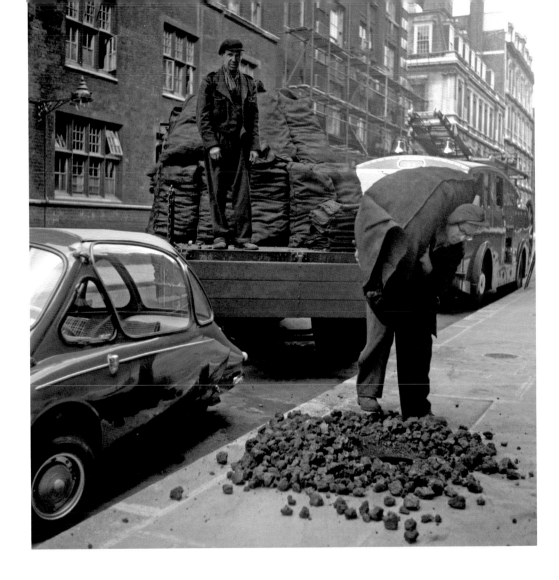

Harold MacMillan is returned as MP for Bromley, Kent, with a majority increased by over 2,300, and becomes Britain's Prime Minister in a sweeping General Election win.
9th October, 1959

Facing page: Having reversed their lorry gingerly between a fire engine and a bubble car, coalmen deliver a load of coke direct to a basement in London via the coal hole in the pavement.
5th September, 1959

Blackburn Rovers and England captain Ronnie Clayton with his wife Valerie at their newsagents shop in Darwen, Lancashire.
23rd October, 1959

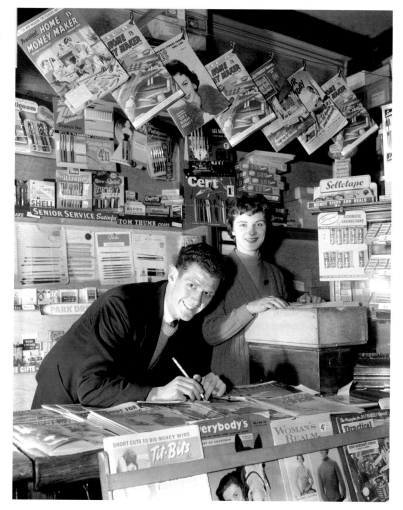

Facing page: Brenda Harcer wears an anti-smog crochet hat, designed by Gina Davis.
13th October, 1959

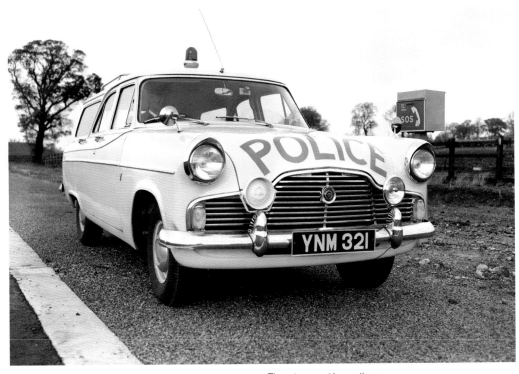

Three transport innovations:
a new style police car stands
alongside an SOS telephone
for motorists in trouble, on
the Bedfordshire section of
country's first motorway –
the M1.
27th October, 1959

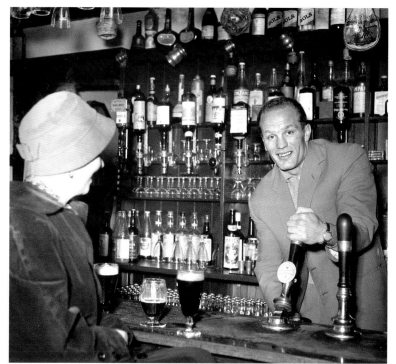

Pulling pints rather than throwing punches, a smiling Henry Cooper lends a hand behind the bar of *The George* public house. 'Our 'Enery' was set to defend his British and Commonwealth title against Welshman Joe Erskine the following month. Cooper would win the fight when the bout was stopped by the referee in the 12th round, with the challenger hanging almost unconscious from the lower rope, victim of the champion's powerful left hook.

30th October, 1959

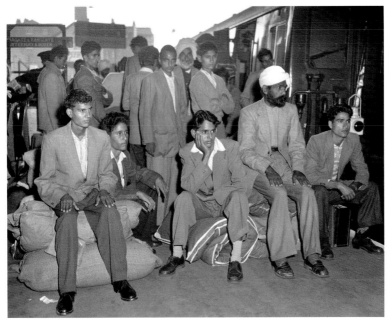

Thirty men from India were permitted to enter Britain after enquiries were made about their passports at Victoria Station, London.
1st November, 1959

Facing page: Britain's first long distance motorway, the London to Birmingham M1, after being opened by Ernest Marples, Minister of Transport. This picture was taken near the Luton spur.
2nd November, 1959

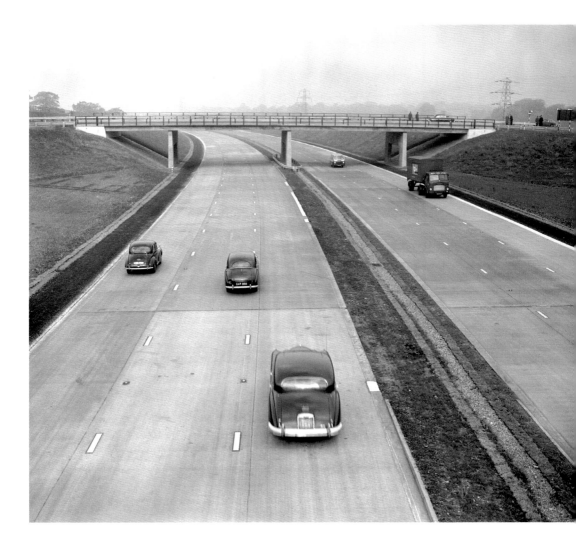

Welsh actor, singer and comedian, Harry Secombe, poses as a photographer in his television show *Secombe at Large*.
6th November, 1959

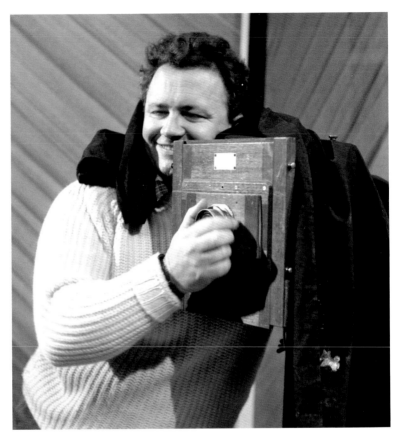

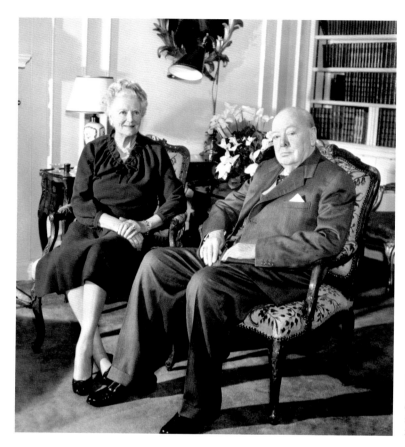

Sir Winston Churchill and
Lady Churchill at home
on the occasion of the
statesman's 85th birthday.
30th November, 1959

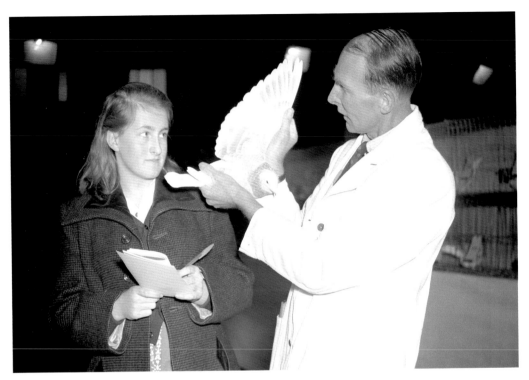

Racing bird. Tom Winter and his daughter Beryl judge a pigeon at the International Racing Pigeon Show, Royal Horticultural Hall, London.
4th December, 1959

Facing page: Supersonic bird. Dr Barnes Wallis, who had collaborated on the R100 airship and the Vickers Wellington bomber, and had developed the 'bouncing' bombs used by the Royal Air Force in the 'Dambusters' raid, contemplates his latest scheme, the supersonic Swallow variable-geometry aircraft. A number of models were built to test Wallis' theories, but defence cuts brought an end to further development, although the Americans used this variable-geometry ideas on the General Dynamics F-111 bomber.
31st December, 1959

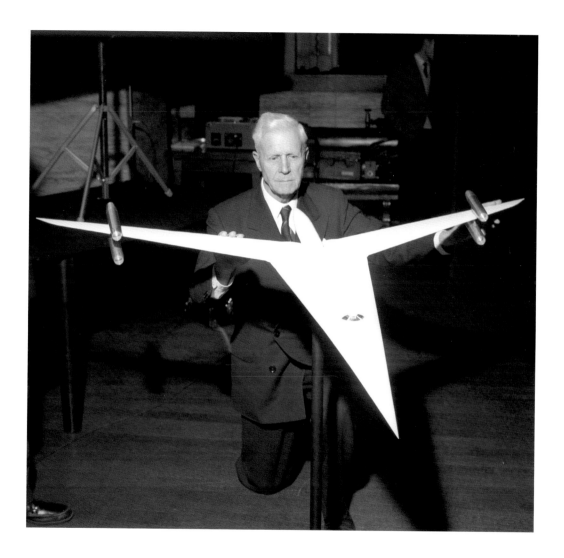

The Publishers gratefully acknowledge Press Association Images, from whose extensive archives the photographs in this book have been selected. Personal copies of the photographs in this book, and many others, may be ordered online at www.prints.paphotos.com

AMMONITE
PRESS

PRESS
ASSOCIATION
Images